SURFACES & TEXTURES

A Visual Sourcebook

SURFACES & TEXTURES

A Visual Sourcebook

POLLY O'NEIL

A & C Black

To my husband Roger, to my family, and to the memory of my late parents, Lily and Jack Byrne.

First published in Great Britain in 2008
A & C Black Publishers Limited
36 Soho Square
London W1D 3QY
www.acblack.com

ISBN: 978-07136-8859-7

Reprinted 2011

Book design by Penny & Tony Mills
Cover design by Sutchinda Rangsi Thompson

Cover images: All photos by Polly O'Neil.

Frontispiece: Part of a skip. Photo by Polly O'Neil.

Printed and bound in China.

This book is produced using paper that is made from wood grown in managed, sustainable forests. It is natural, renewable and recyclable. The logging and manufacturing processes conform to the environmental regulations of the country of origin.

Acknowledgements

Thanks to my husband Roger for his kindness, practical help, and support with this book and throughout the years. My thanks to all my family and friends for their encouragement, but particular and special thanks to my son Joseph, who checked through my work and made such inspired suggestions. I would also like to thank Alison Stace and all the staff at A&C Black, who gave me the opportunity to write this book.

Contents

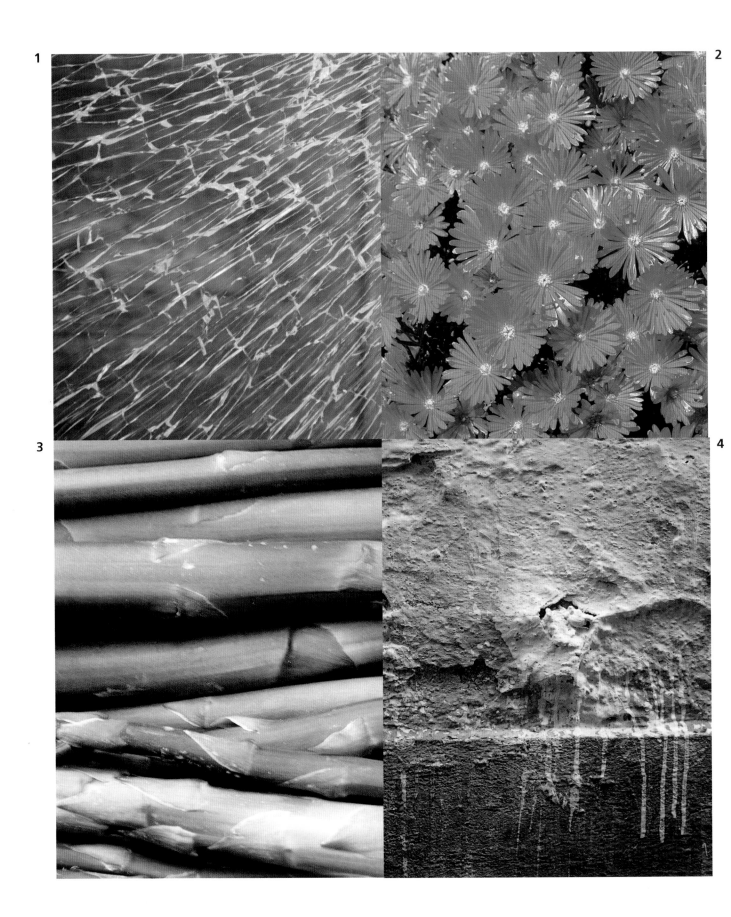

Introduction

(Narrative) is simply there, like life itself.

Roland Barthes *Aporias of Writing: Narrative and Subjectivity*

Surfaces surround us, offering intrigue, mystery and fascination. Some are manufactured, some natural, some new, and some eroded and old. They hold a record of their own history, and every single one has its own silent narrative. Look at any surface; it has a tale to tell.

I am alive to marks, surfaces, and randomly found patterns such as those left by stacked logs or bricks. Some marks may emerge on eroded, time-weathered materials such as blistered paint; some may have evolved naturally, like decaying rhubarb leaves; some marks were made accidentally, such as tyre tracks in thick mud; and some deliberately, like the knife cuts on a leatherworker's bench. I am simply delighted and grateful to have found them.

Marks can be accidental (concrete or paint splashes) or intentional (stacked wood or messages left in code by one workman to another) or as a result of nature (rust or acid-bright lichens). Sometimes, unintentional, unexpected patterns emerge such as mould spores on fallen pears. Some surfaces stand in their own right as just being beautiful, such as the fishing nets found in Greece.

Initially, it was the pure and stunning beauty of these surfaces and patterns that drew me in. Consequently, I have accumulated an eclectic collection of seemingly random images.

I began wondering how some of these surfaces had formed. Time was an obvious element in this equation. I love the thought that some marks and surfaces, such as those on rocks, have evolved naturally over thousands of years;

1 *Shattered glass in a workshop window at San Donato, Tuscany.*

2 *Flowers in Pisa, Italy.*

3 *Purple asparagus stalks on an Italian market stall.* -

4 *A paint-splashed wall in Florence.*

some trees have taken hundreds of years to grow their textured bark; while sun-bleached and blistered paint surfaces may have evolved over a mere decade or so. Equally, messages left by workmen to their colleagues, or indeed most graffiti, may have sprung up overnight. What was being said or done, and why, and by whom? They are ripe for interrogation, pregnant with meaning.

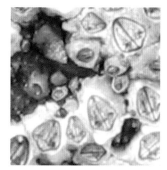

Surfaces and patterns contain coded histories, and it is absorbing to ponder their meaning. The purpose of some are more obvious than others, such as the work-men's written messages on the London Underground wall, but some are more mysterious in creation and intention, and we may never know their meaning or age. The photograph has frozen the moment and thus time has stood still, though it is fascinating to think that time still continues to weather the original piece.

Public notice boards provide a historical montage of the life of an area when torn snippets of previous posters have been left behind for us to consciously or unconsciously decode if we wish, or merely to enjoy their tattered, colourful remains. A cracked, dried, abandoned French mussel bed speaks of the weather patterns and the local fishing industry in that area. Scratches, graffiti, dents and rust contain a wealth of silent narrative about the location, social structure, weather patterns and age of a skip, whether it is a public one left by the council or a private skip outside a house – and that is without considering the contents.

I have recently discovered Wabi-sabi – the Japanese philosophy hovering around the borders of Zen Buddhism. This elusive discipline, which is hard to define, gives emphasis to beauty possessed by humble, unconventional, unpretentious things such as rust, cracked dried earth, simple ceramic pieces, unpainted wood and its grain, and leaf patterns. Attention is given to the simple, the natural, the quietly austere – ephemera, artefacts and areas which would not normally be noticed, like many of the surfaces photographed in this book. There are quiet moments of beauty in the overlooked and undervalued.

My collection of photographs has evolved organically over time to become a long-term gathering of apparently random images which have become a part of the surface of my life. Since starting my collection ten or so years ago, I have found myself increasingly tuned in to the potential beauty of surfaces around me.

Now I am borderline-obsessive about carrying a camera with me most of the time, after many frustrating moments when I have come across what could have been stunning images only to realise that my camera is at home. In addition, there have been occasions when I have returned to a place to photograph a surface to

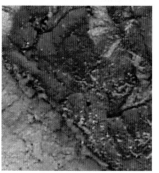

find it either gone, covered up or repainted. A friend once telephoned me to say she had seen a wonderfully rusted dumped car. I raced to the site, only to see the car disappearing over the hill behind a tow truck.

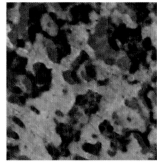

Often opportunity arises but does not fulfil your expectations. I arranged with some workmen to photograph the inside of a house that they were about to demolish. The light was right, the conditions were good and I was able to gain access. Unfortunately, although I searched all over the house, the exciting degraded surfaces I had fondly imagined just did not exist, at least not to my eye.

My cameras are modest. The first was an Olympus Zoom 105; then an Olympus digital camera – a C-370 Zoom, and I now use a Canon Digital IXUS 900Ti. For me, cameras have to be portable and straightforward to use, partly because I am not a camera buff, but also because there have been times when I've had to snatch the opportunity spontaneously and immediately. Where possible, I try to fill the frame with my subject material and get as close up as I can. I like to see the surface removed from its context and where possible without the distraction of areas around it. Some of the images bear little relation to what they are capturing when viewed in such a way, but I still consider them intrinsically beautiful in their own right.

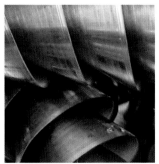

Defining the subject matter has been very difficult in many cases. Some have been clear-cut – it would be obvious, for example, that curling paint should go into a chapter about paint. But what about a heavily rusted skip? Should it be classified under Skips or Rust? Thus you may notice some crossover of subject material, though I have tried to mitigate that by considering what it was about a particular photo that caught my attention at the outset.

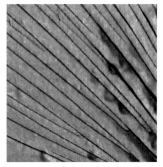

I hope that the images being presented in this book will inspire readers to look more sharply at the world around them and to really get in close. Although certain photographs have been taken in countries other than my own, many have been taken in the area where I live or have worked. One or two have been marks that have completely surprised me, such as the colours and shapes from roasted meat left on the bottom of a glass cooking dish. Who would have expected that to grab the attention?

It is simply a case of *really* looking, being open-minded, and developing an awareness of your surroundings. Once this happens, it is astonishing to discover the fascinating, haunting beauty which is there for all to see – if only we would just take the time to look.

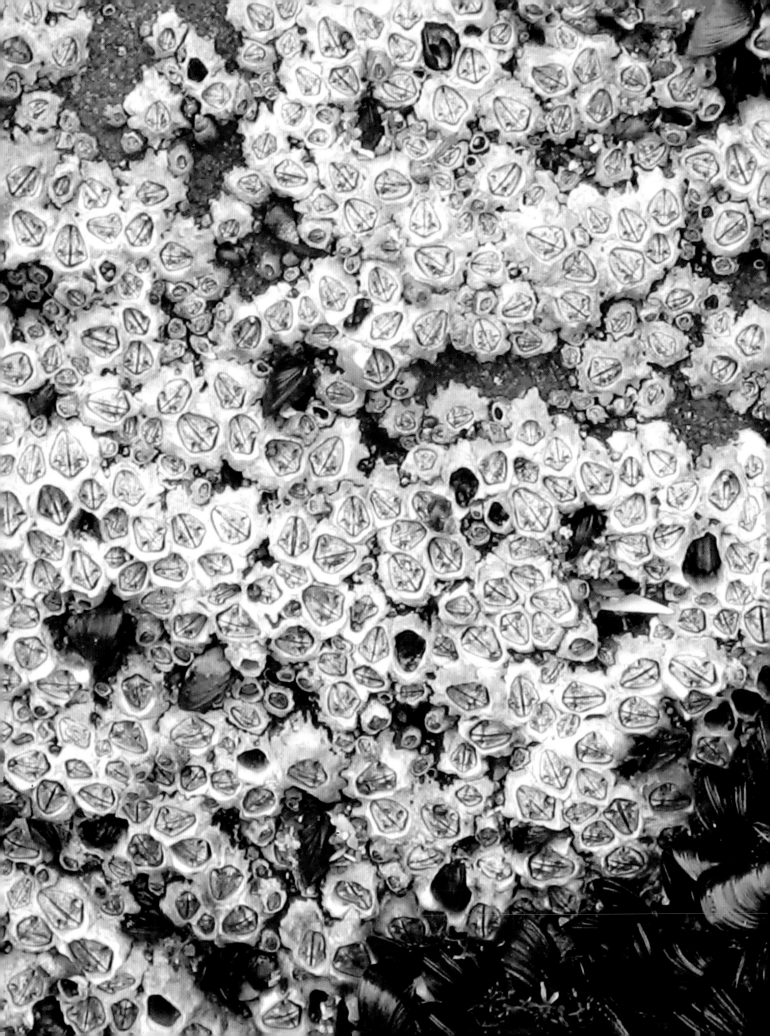

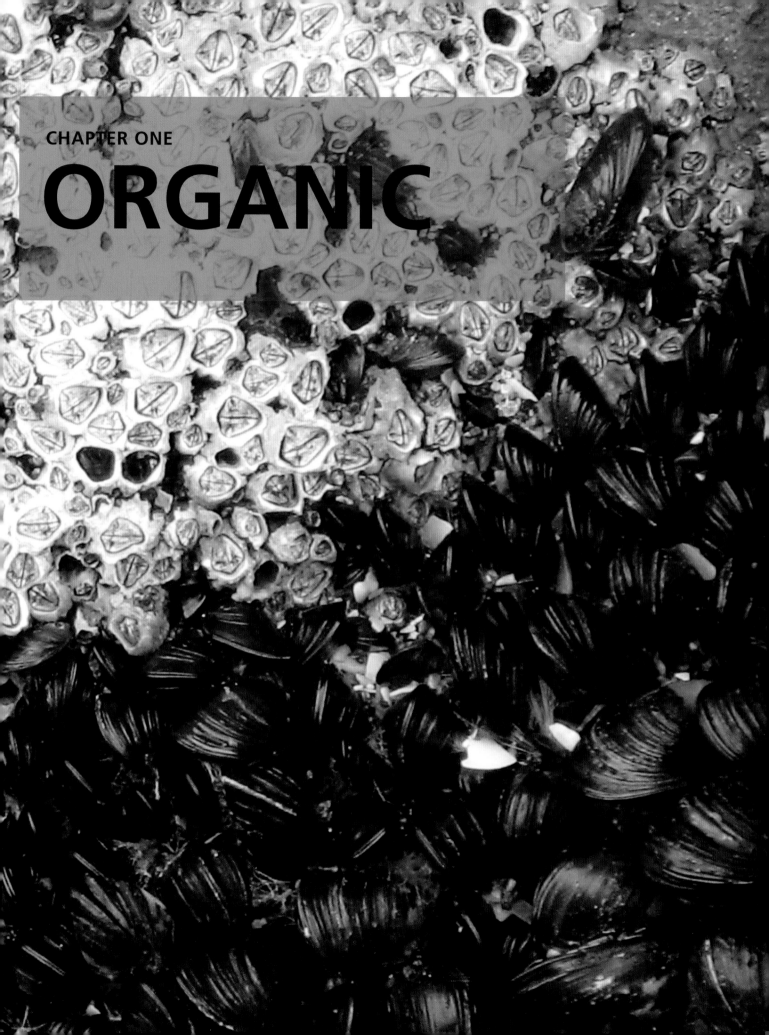

ORGANIC

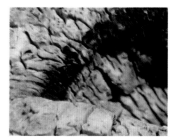

This title covers such a variety of categories that it is hard to know where to start making some order of it all. What does the word 'surfaces' mean? Can the view of leaves on trees, or the sky or the sea, be said to have a surface in the same way as does lichen, rust or peeling, painted wood? That's something to reflect on.

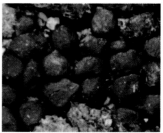

The camera captures the 3D images we live with from moment to moment, and renders them 2D, turning everything into a visible surface of sorts. When I am excited by an image, I just feel compelled to photograph it, so as to capture it and gather it into my ever-growing collection.

Why do we reject, or at least scarcely notice, one scene or image, and yet find another stimulating and exciting, motivating us to record it? On one level we should simply accept that as diverse individuals we are all drawn to different things, but it does also seem that human beings are drawn to some things as a species.

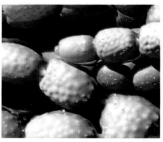

The beauty of some images is more obvious than others, although this certainly does not demote the more humble ones, which are probably more subtle and need the viewer to look more carefully. Sometimes we need to get really close to something, perhaps using a macro lens to clearly see potentially exquisite detail. Sometimes we just need to get our eye attuned to the myriad possibilities that surround us. Simply slowing down can sometimes be the key.

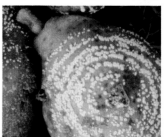

Despite the debatable classification of sky or water as a surface, I felt that I couldn't leave out one or two spellbinding images, such as those showing a spectacular English sunset, where the evening sky was a glorious riot of tangerines, golds, ambers and lavender purple-blues, and, equally, the image of the sea gently lapping the beach on the Kapiti Coast in New Zealand, reflecting and stippling the blazing, fiery-hot sunset colours from the sky in the water as the light is fading.

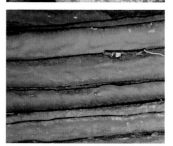

Conversely, it could be seen as a curious thing to include a photograph of rabbit and sheep droppings found on a coastal walk near Salcombe in Devon, but once you look beyond what they actually are, they become just another texture and composition. I really liked the neat, round uniformity of the dark chocolate-brown rabbit droppings against the more random, paler hazel-coloured sheep dung. I enjoyed the neutral colours of the small-scale, pearly-

grey gravel of the path set against those of the droppings, as well as the shape of this unusual arrangement.

At the end of the garden during late summer I came across slowly decaying pears and rhubarb leaves lying in the grass. Although all of the pears were rotting, some had extraordinary circular mould marks on them. They almost looked as though they had been drawn deliberately. Why do spores of mould grow in this graphic and beautiful way?

The rhubarb leaf lay like a large multicoloured elephant's ear. In its state of decay most of the fresh green had evolved into an Alizarin crimson- and Naples yellow-coloured flush. The only way I could preserve the beauty of these found organic objects, and indeed most of the objects in this chapter, was to photograph them before they completely decomposed or changed, and were lost.

I was stopped in my tracks on two New Zealand beaches at Kaikoura. On the first, soft, smooth, rounded charcoal-grey pebbles on the beach were gilded with incredible, thick tangerine ribbons of seaweed. On the second beach further along the peninsula, en route to a seal colony, my attention was caught by small, delicate strings of pale olive-green seaweed, called Neptune's necklace, nestling among the rocks. There were also large brown-and-buff dehydrated clumps of seaweed, which had wonderful patterns and marks on the base.

The examples I have given you may give a flavour of this chapter, and there are many others that I trust you will enjoy. Like me, once you start looking for these images, you will be surprised how many you find.

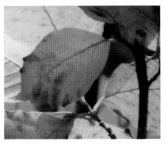

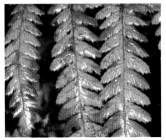

1 (*Previous double page*) *Silver-grey barnacles and charcoal-coloured mussels compete for a rock surface in New Zealand.*

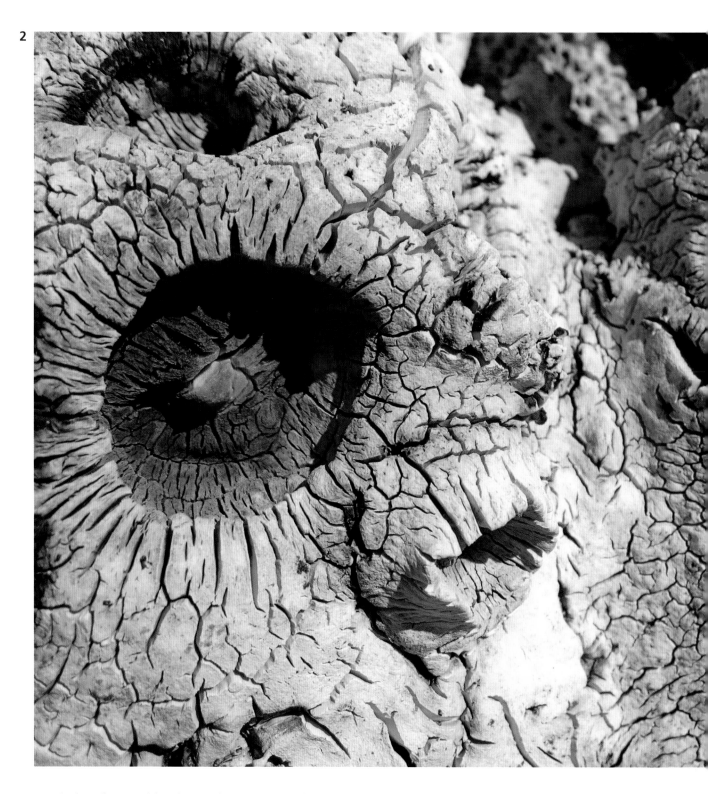

2 Dehydrated seaweed found at Kaikoura, New Zealand, near a seal colony.

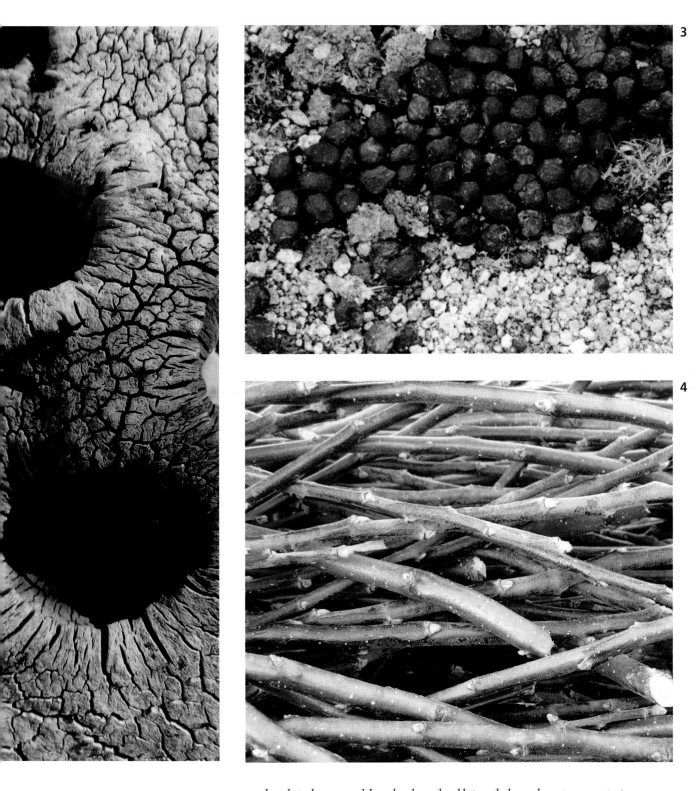

3 Chocolate-brown and hazel-coloured rabbit and sheep droppings against neutral-grey granite chips found on Dartmoor.

4 Cut and discarded twigs.

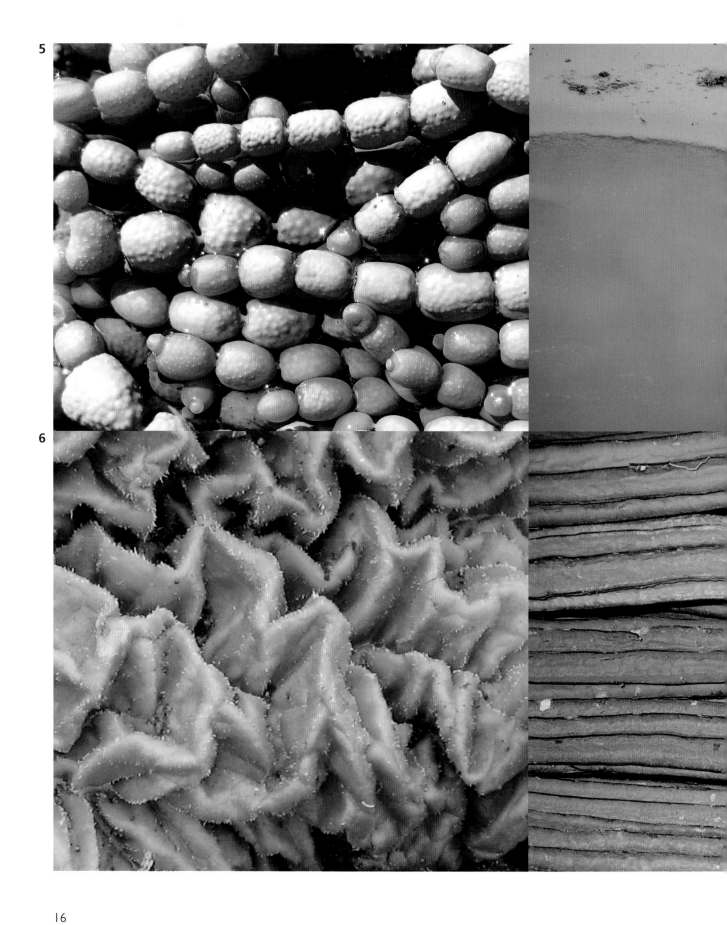

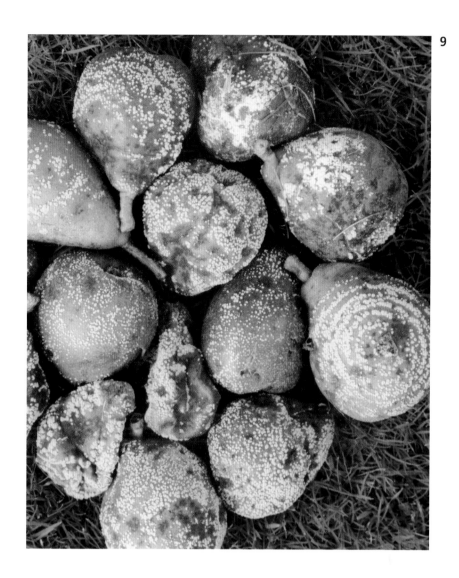

5 Neptune's necklace seaweed found in abundance on the Kaikoura Peninsula, New Zealand.

6 Newly grown rhubarb leaves.

7 Jade-green tones in a thermal pool at Wai-O-Tapu in New Zealand.

8 Ribbed green bitter melons on a market stall in Hong Kong.

9 Mould on pears found in a back garden in Surrey.

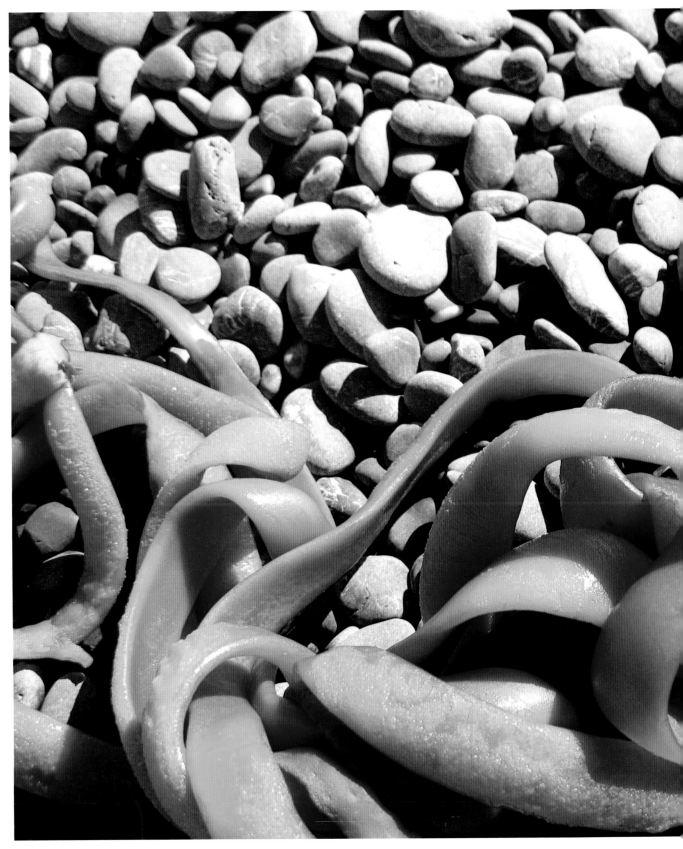

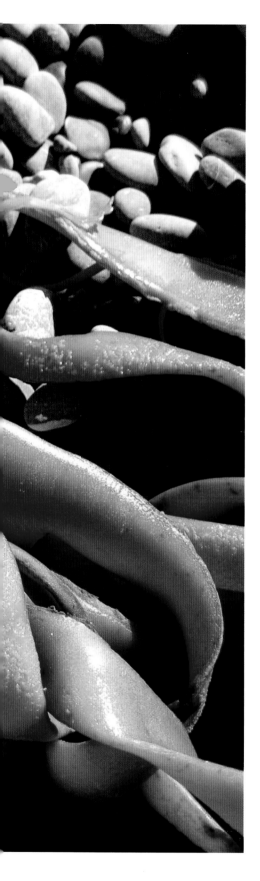

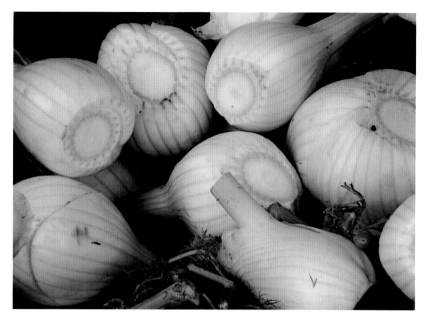

10 *Vivid orange ribbons of seaweed undulating against dove-grey beach shingle in Kaikoura, New Zealand.*

11 *Fennel bulbs on a Venetian market stall.*

12 *(Overleaf) This soft and grainy photo of roses in their cellophane wrappings was taken at a New York market stall.*

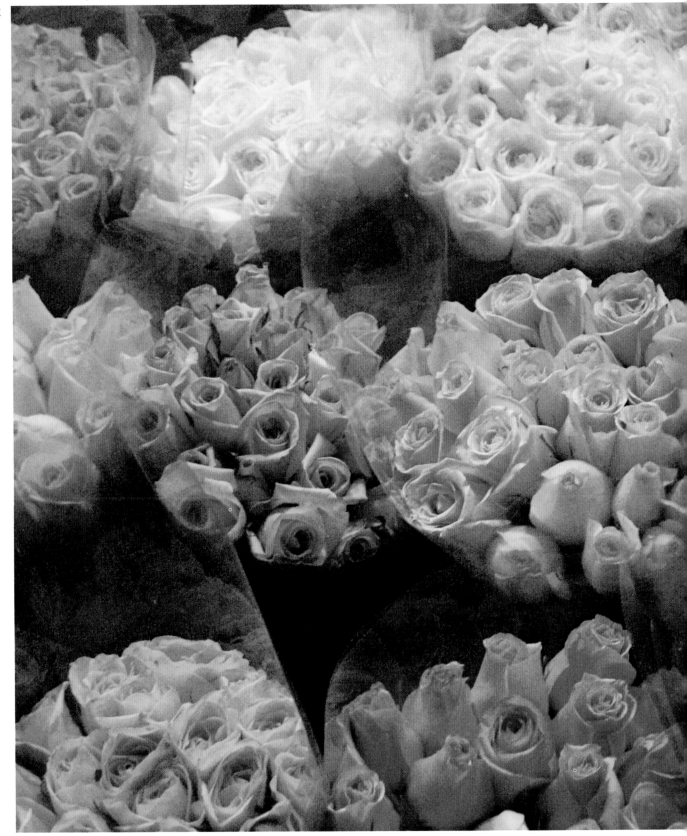

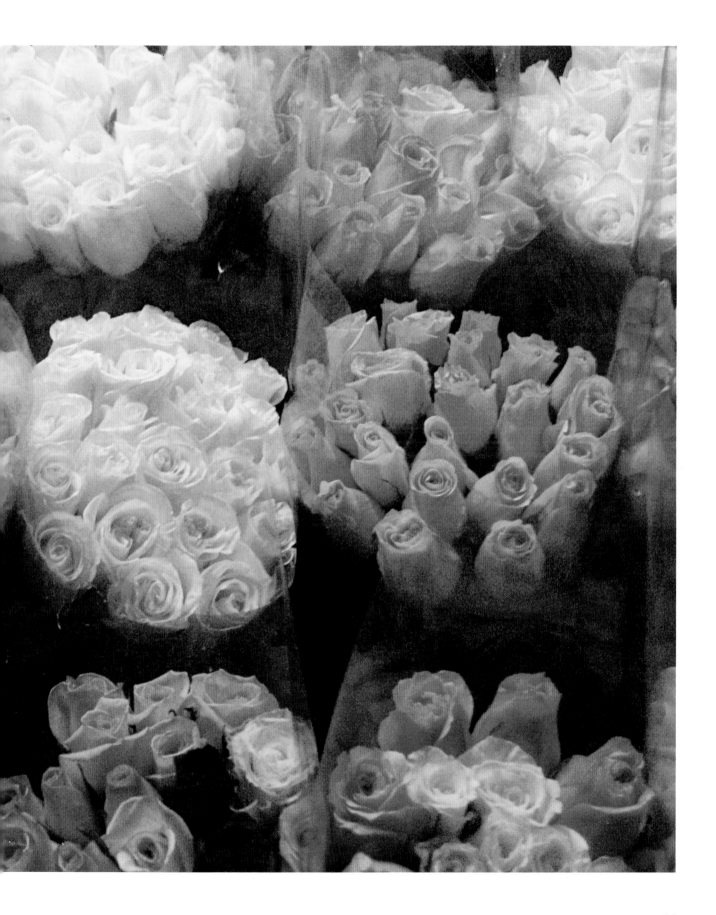

13 A crimson and yellow decomposing rhubarb leaf.

14 Orange and grey rocks in the Champagne Pool at Wai-O-Tapu.

15 Vermilion dates on a market stall in Hong Kong.

16 The bottom of a glass dish in which meat has been roasted.

17 Amber-coloured fern leaves in the Ngaiotonga National Park, New Zealand.

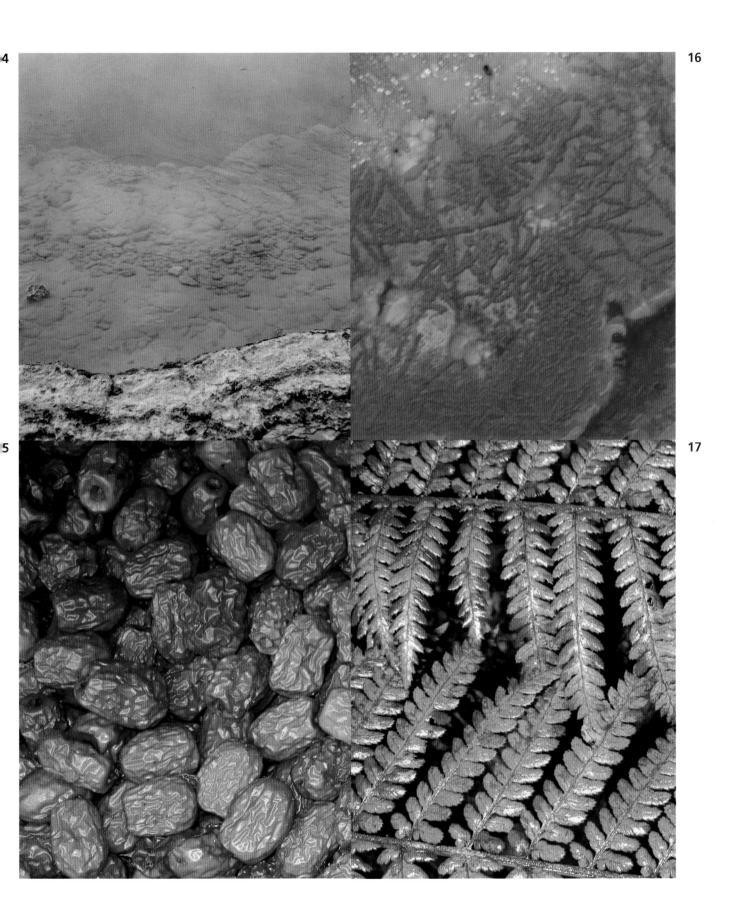

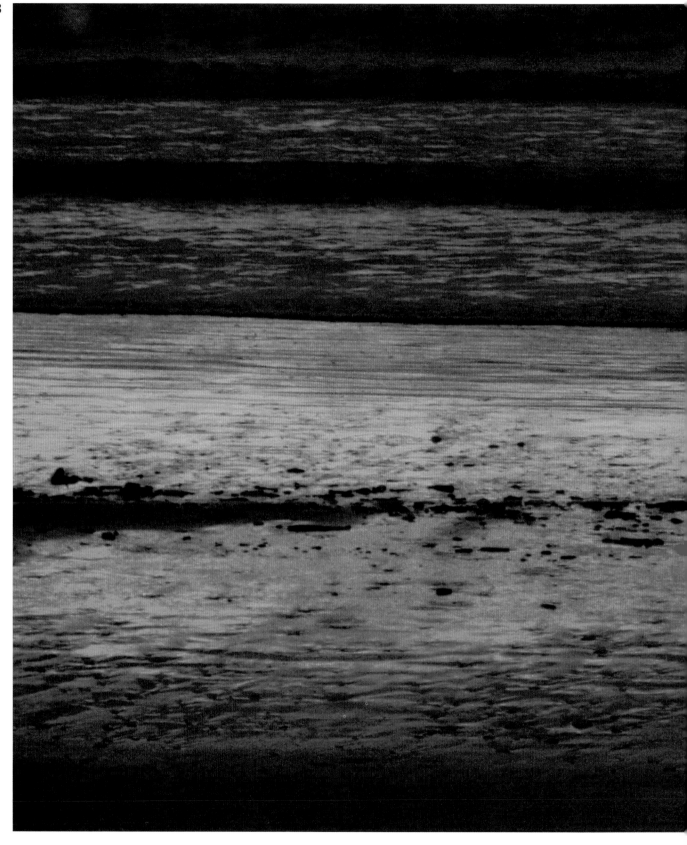

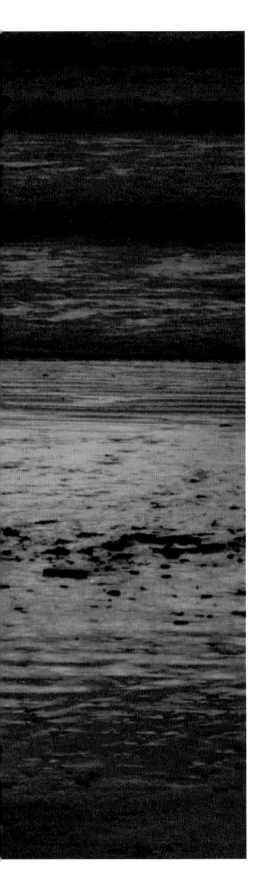

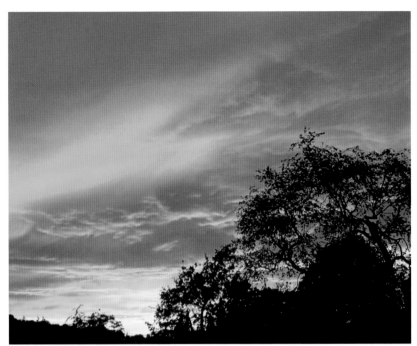

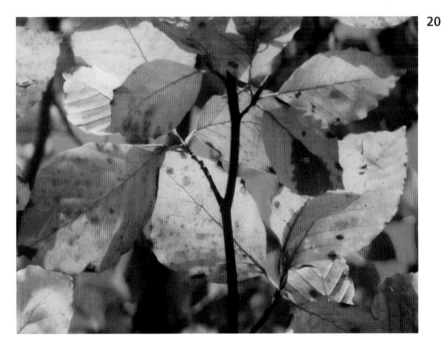

18 Sunset reflected in the sea at Paekakariki, on the Kapiti Coast, New Zealand.

19 A fiery sunset in Surrey.

20 Copper-beech leaves against a blue sky.

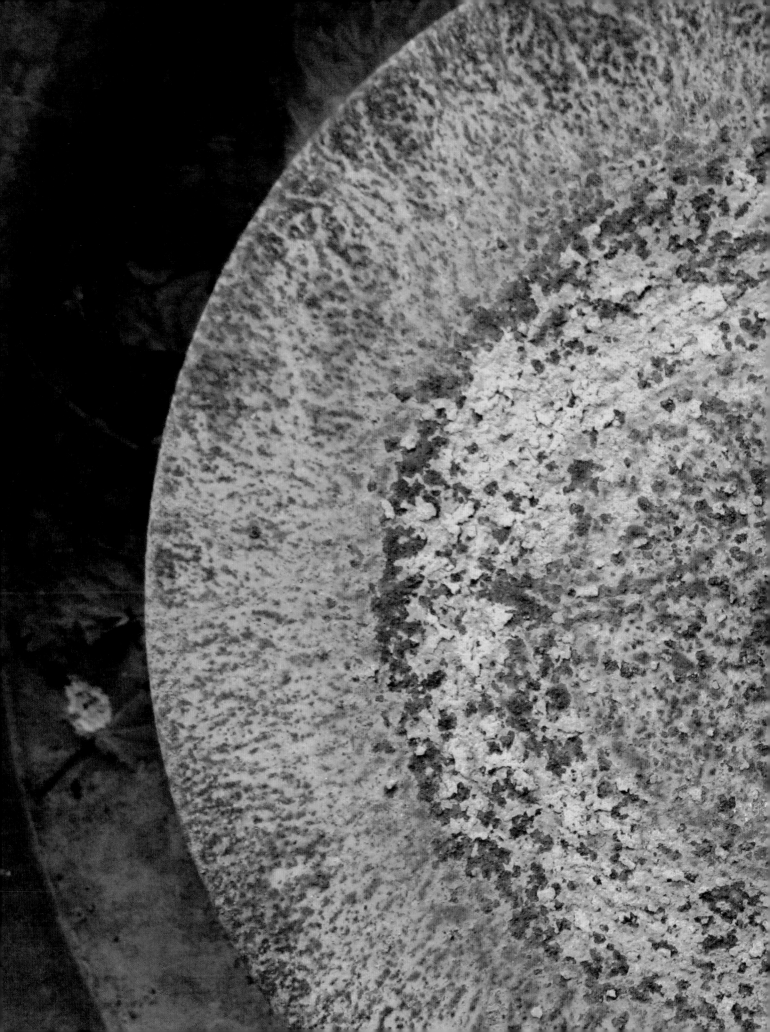

CHAPTER TWO

RUST

Russets, ochres, oranges, golds, siennas, umbers: the exploding sunset of sumptuous rust colours is exciting. Consider yourself particularly lucky if you see them illuminated by sunshine, bringing the colours to life. Depending on the metal or surface affected, there can be a wide palette of shades and varying degrees and textures of rust. Where many see only destruction, I see creation and beauty.

The combination of water and oxygen forms a powdery or scaly reddish-brown material on iron or metals containing iron. This is hydrated ferric oxide, or rust. One area of the metal has a positive charge and another a negative one. Water acts as a conductor, allowing currents to flow between these two areas. The metal absorbs oxygen from the water, gives up an electron, and so rust is formed.

Some surfaces are only slightly touched or coloured by the oxidation that must take place in order to allow the process of rust to begin, but where this degradation has taken hold, or has been longstanding, the underlying metal is sometimes eroded to such a degree that the surface has been eaten away, creating a colourful, miniature landscape. I have seen metal on the lid of an old covered skip eroded to such an extent that it had taken on a fragile lace-like quality. When viewed from beneath, the blue sky could be seen through the gaps in the metal, giving it the most wonderful complementary colours.

Areas of the Rochester skip were so beautiful that I had to include a selection here. Despite it being the same skip seen from various angles, the rust seems to have interacted differently in each image, providing alternative but equally interesting textural surfaces, shapes and colours.

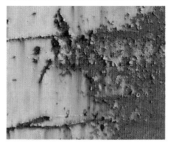

Rust can affect painted areas by working into the paint, slowly chipping, lifting and blistering it from the metal surface. This in turn creates interesting shadows, marks and colours which can complement the shades of rust.

Sometimes, however, rust seems to intermingle with the remaining paint. A large, corrugated-iron sheet washed up on a Devon beach has the remnants of spent jade-green paint gradually blending with the encroaching rust.

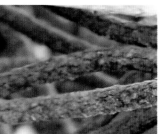

Metal scaffold supports have left their rusty ghost imprints on wooden planks found on a pavement in Dorking, Surrey, leaving behind

a hint of the work that may have taken place there. To me, it is almost like overhearing the echo of someone else's conversation.

A busy, tangled jumble of bronzed and rusted fencing wire washed up on a beach in New Zealand appeared to be covered with a faint frosting from the sea and the salty air – part of the process of erosion, no doubt. The chaotic mess of metal rusting away on the beach acted like a magnet to me – I simply had to photograph it.

I loved the rusty old ice-cream advertising sign found in a Greek village but curiously written in what look like English words. It was half-hanging from a wall on the front of an old building in the throes of renovation. I liked the way the colours of the ice creams have faded and weathered to a blue-grey, and then been incorporated by the rust.

Look at the photograph of the underside of a wheelbarrow. Apart from the fact that the bright-blue and coppery colours naturally enhance each other, the paint has chipped away in large, almost angular flakes.

Despite all the many different rusted artefacts I have seen, photographed and admired, my favourite rust image remains the drain inspection cover that was on part of a beach near Salcombe in Devon. I saw it in dull and sunny weather, and although it was at its best illuminated by the sun, it never failed to be anything other than beautiful and inspirational to me. The tide washed over it, day in, day out, and it had the most glorious array of rust colours, from gold and ochre all the way through to dark browns and black. The surface was also flaking, pitted and decayed in a way that added to its interest – it could have been an abstract painting or sculpture and would not have been out of place in Tate Modern.

Enjoy Rust …

1 (Previous double page) Rusted potter's wheel found in Redhill, Surrey.

2

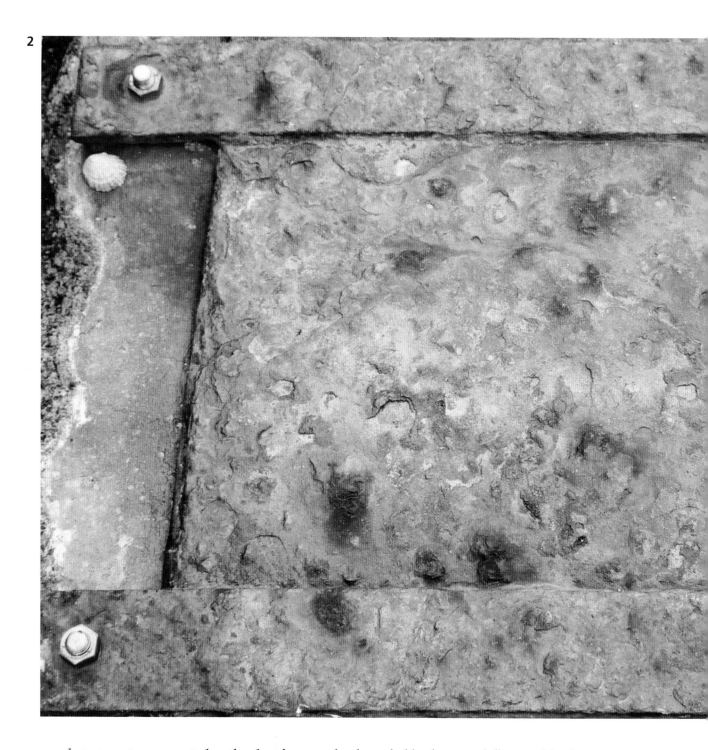

2 A drain inspection cover, sited on the edge of a Devon beach, washed by the sea and illuminated by the sun.

3 Rust marks from a scaffold plate on a plank.

4 Rusting reinforcement mesh.

5 An eroded chunk of metal has flaked away from this metal drain cover found in St Ives, Cornwall.

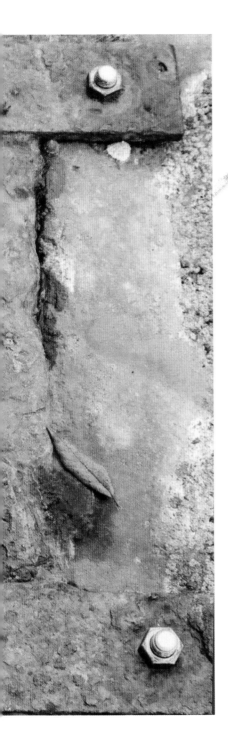

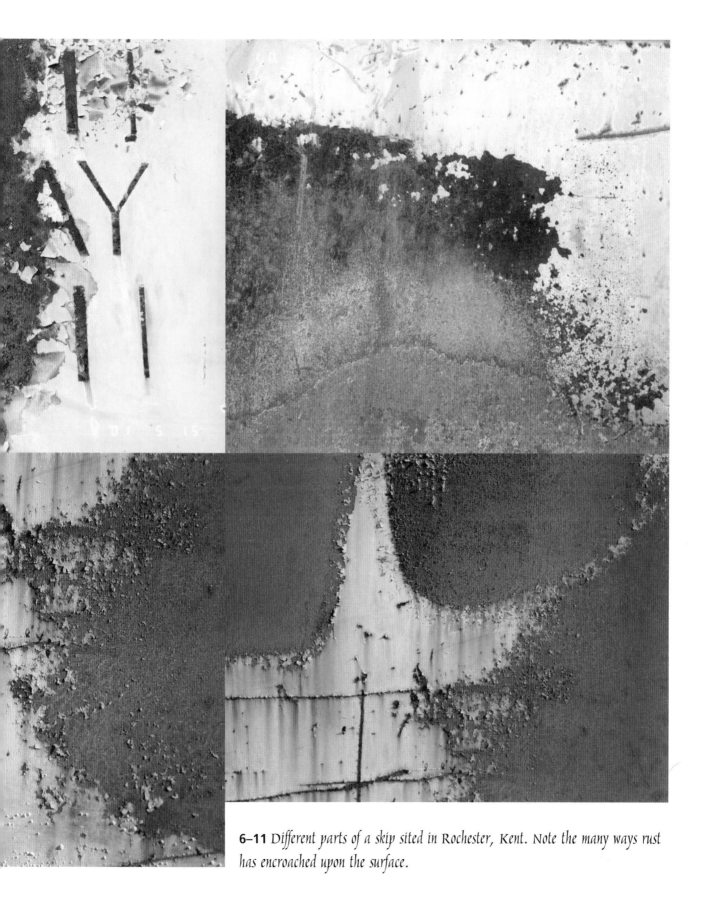

6–11 *Different parts of a skip sited in Rochester, Kent. Note the many ways rust has encroached upon the surface.*

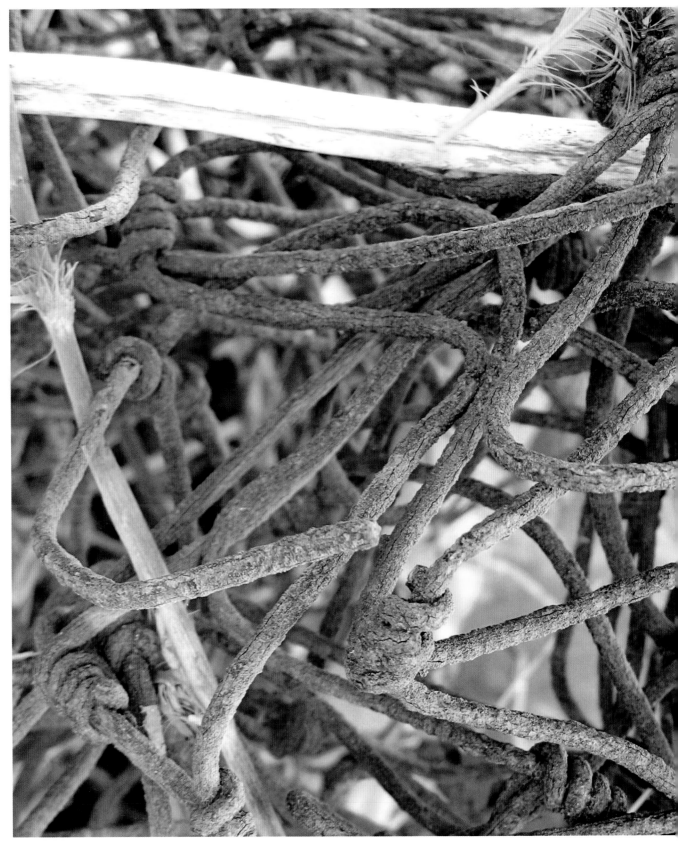

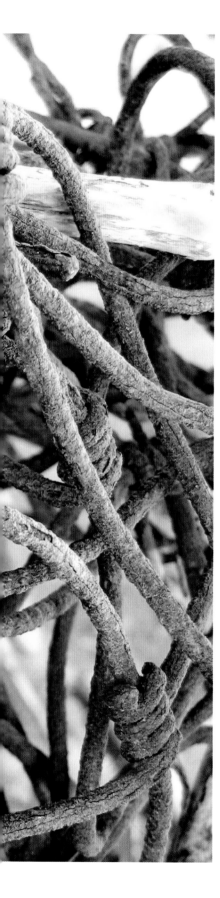

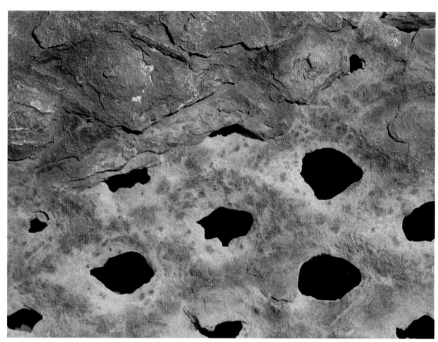

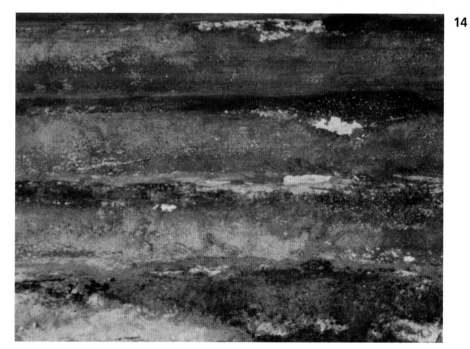

12 A tangle of rusted fencing wire found on a beach in New Zealand.

13 A rusted drain cover on the harbour at Montorosso al Mare, part of the Cinque Terre National Park, Italy.

14 Remnants of jade-green paint intermingle with the rust on this corrugated-iron sheet washed up on South Sands beach in Devon.

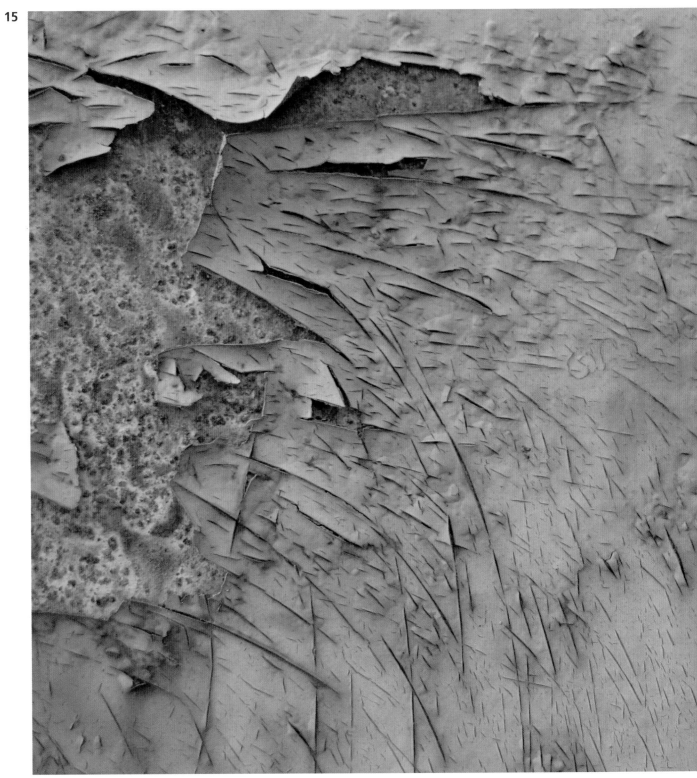

15 *Faded blue paint splintering to reveal rust on the skip exterior.*

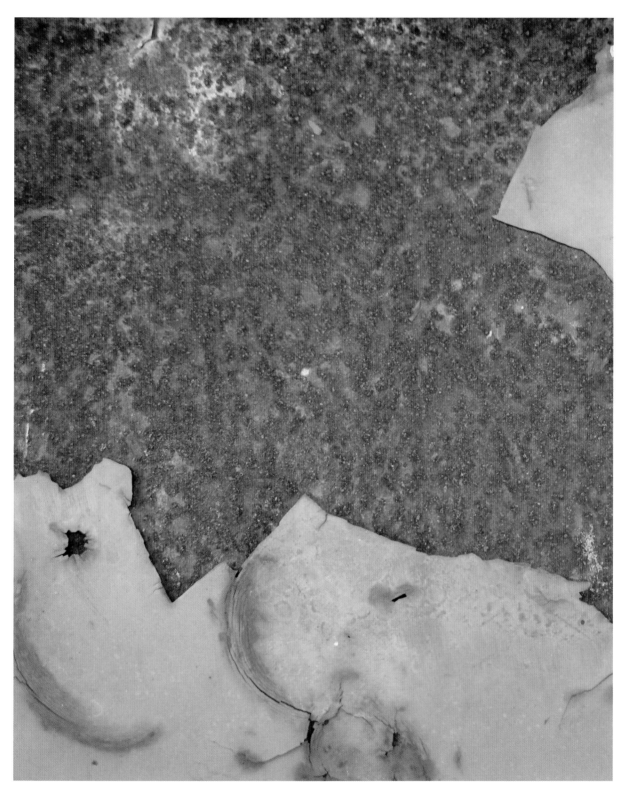

16 *Chunks of blue paint have flaked and peeled away from the underside of a wheelbarrow.*

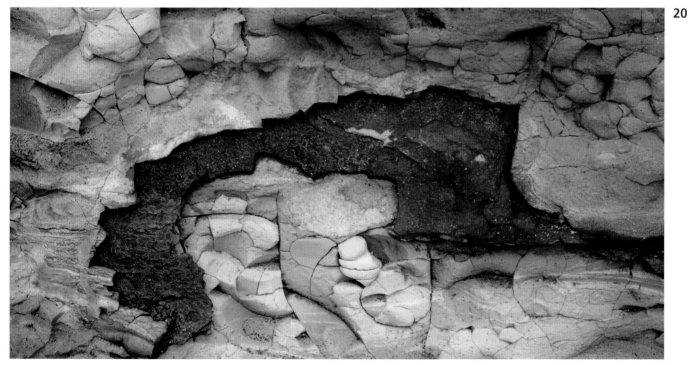

17 A rusted enamel advertising sign in Greece, uncovered by workmen, during renovation of a building.

18 Rust marks on a painted concrete wall near Tate Modern in London.

19 Mottled rust on the side of an oil drum.

20 Areas of rust in a sandstone cliff face in New Zealand.

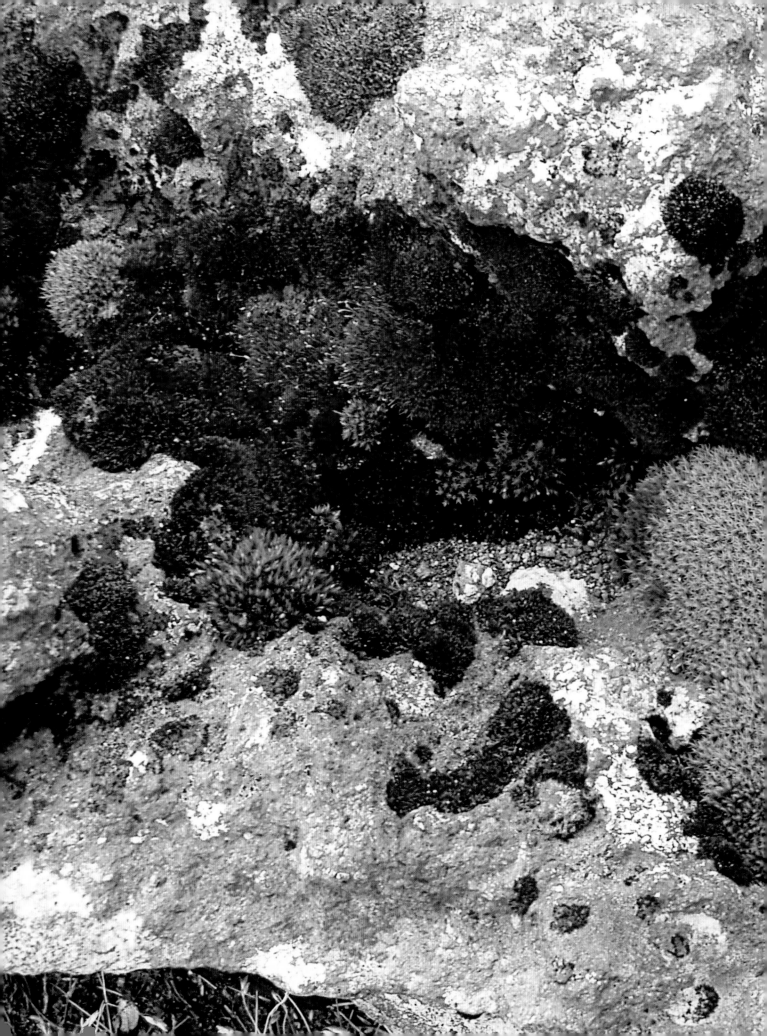

LICHEN

cid-yellow ochre, soft sage-green, grass-green, granite-grey, orange-red and black – with small, subtle explosions of colour, shape and texture, lichens encompass a wide range of hues, structures and organic forms.

Lichens are not a single species, but a symbiosis between algae and fungi. They can thrive in the most inhospitable habitats – cold lava flows, bare rocks, and windswept areas – and there are estimated to be up to 17,000 species on Earth. I have heard that lichens flourish in pure, unpolluted air, something I really want to believe in these days of concern about our planet.

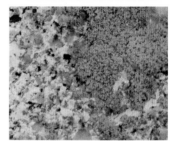

I have only seen and photographed a minute fraction of the lichens that exist, but have nevertheless been captivated by the tenacity, beauty and range of pigmentation of these fascinating examples of co-operative living. Like most people, I had never really looked at lichens until I started photographing them; they were something that blended into the background of life.

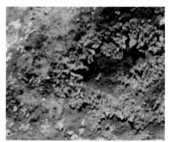

I first noticed rusty-orange blotches on rocks along a coastal walk in Pembroke in Wales, and was struck by their unusually vivid brightness. This discovery awoke me to their beauty, and it seemed that, wherever I walked or travelled afterwards, I became aware of them in their variety of forms and in different types of climate and weather.

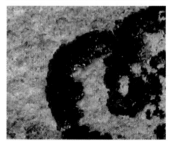

Alongside a beach in Devon were rocks, wet and darkened by the sea and rain. A flamboyant splash of mustard colour above my eyeline led me to climb up to investigate, whereupon I was excited to discover bright-yellow lichen growing on black rocks – a dramatic colour combination which thankfully, as I had remembered to bring my camera with me this time, I was able to capture as an image.

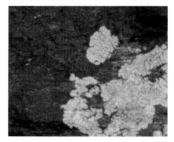

I saw one spectacular example on a partly dry glacial riverbed in New Zealand, near the Franz Josef Glacier. From a distance the riverbed seemed to be covered in red, but on closer inspection I found that the grey rocks, stones and boulders were coated in a bright orangey-red type of lichen. Not only were the riverbed stones simple, rounded examples of pure form sculpted by water, they were beautifully dressed as well.

The magnificent and mysterious monoliths around Avebury have a sprinkling of circular black and grey lichens scattered over them. Many

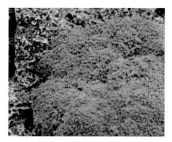

of these marks look like codes and ciphers – almost like a form of undiscovered language or strange script. On first sight, I thought that someone had been drawing outlandishly on the stones, and then I looked more closely and realised that it was simply lichen.

Sometimes, two or three types of lichen will grow and overlap each other on the same rock face or surface, exhibiting a small palette of colours like a living Venn diagram. I have also seen black lichen with a sudden unexpected bright flash of pink in the centre, where perhaps another species has taken up residence.

Looking down from an elevated walkway onto a sea of curving, tiled rooftops in Dubrovnik, I became aware of an orange-red sprinkling of colour. On closer inspection, it was apparent that orange and paler grey-green lichen were growing alongside each other. Some areas of tiles, however, were completely clear, and I wondered why this should be so. Perhaps they were newer, giving the lichen less time to grow.

Old dry-stone walls in the Lake District are glorious anyway, but when covered in a harlequin patchwork of coloured lichens and mosses, it becomes difficult to know where to focus the camera lens; you are so spoilt for choice. These walls seem to go on for miles, too, giving endless possibilities.

I like the roundness of lichens, the circularity of some of them growing so neatly, such as the bright-green specimen overlaying the orange lichen-coated rock. They cover surfaces with such apparent permanence and durability.

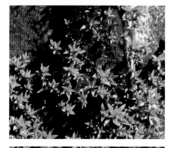

Change your level of observation – get in close. From a distance, depending on the type of lichen, you will see perhaps a flush of colour over bark or rocks, but in close proximity you might see a miniature, multicoloured moonscape of texture. Look around you and discover their beautiful colours and structures for yourself.

1 (*Previous double page*) *Found on the Tongariro Crossing in New Zealand. Lime-green moss intermingled with the orange-flushed rock and chestnut-coloured lichen.*

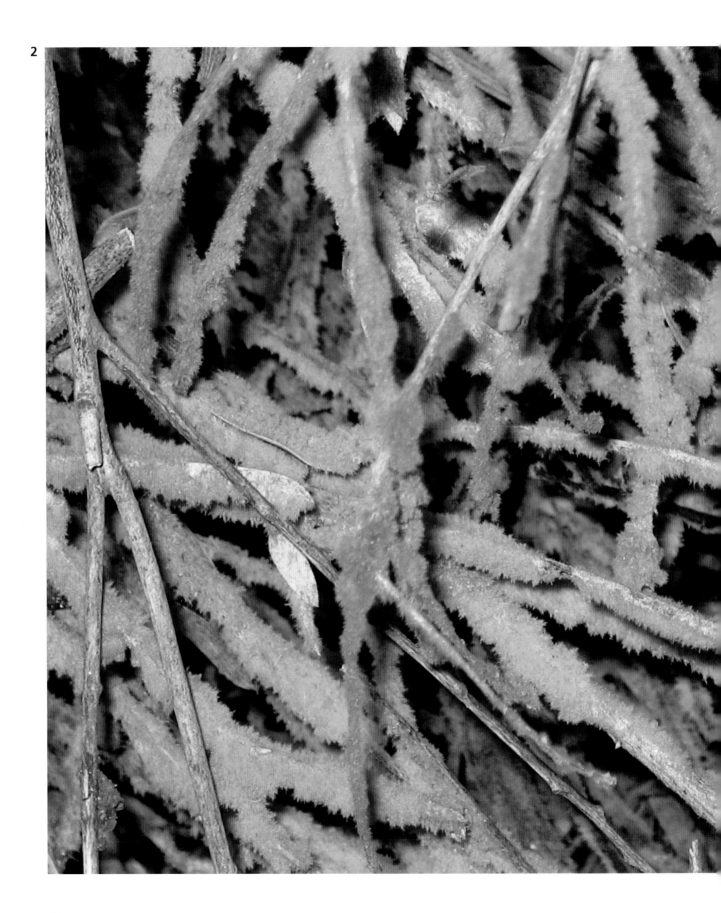

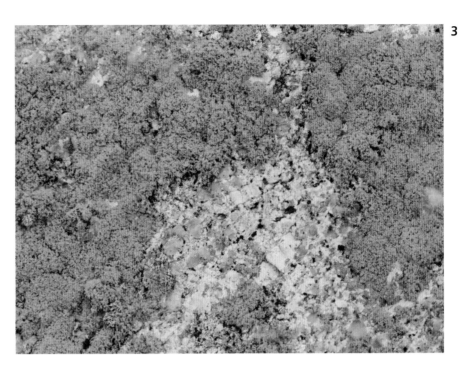

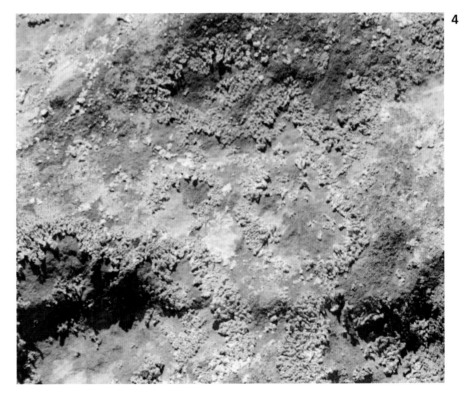

2 *Fuzzy orange lichen on twigs found in Wai-O-Tapu.*

3 *Orange lichen on a stone wall in Pembroke.*

4 *Circular orange lichen on rocks by a beach near Salcombe, Devon.*

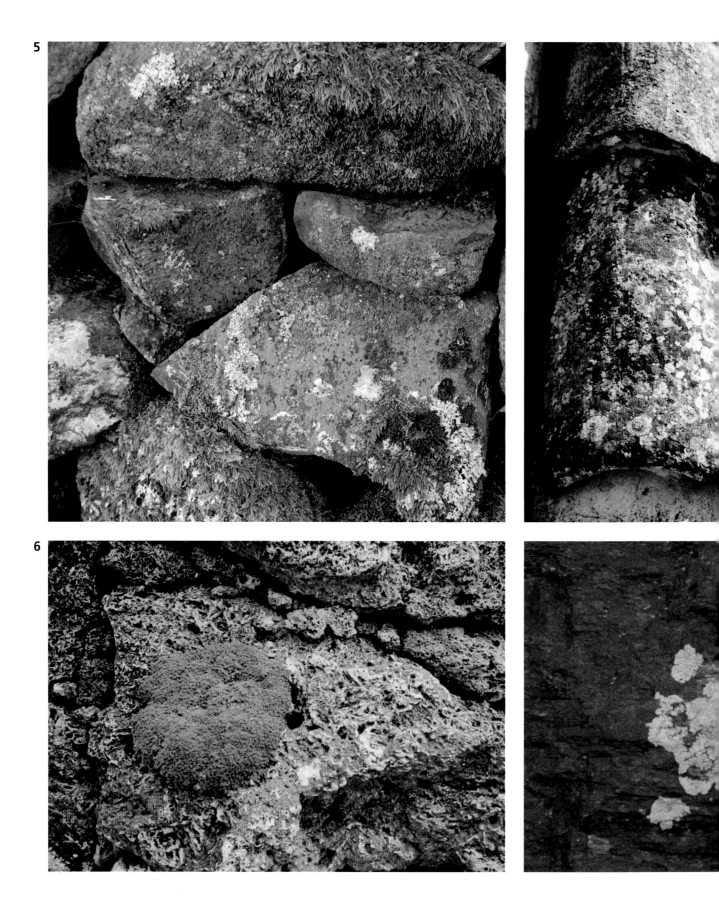

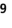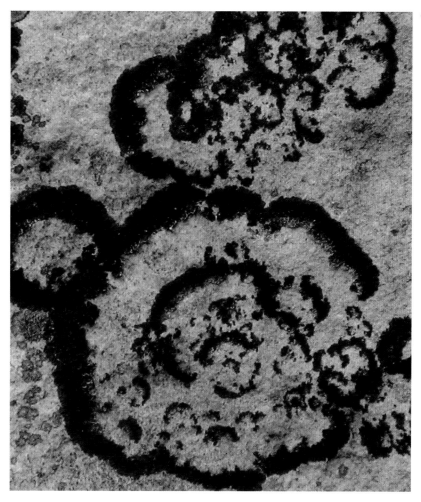

5 Lichen and moss on a Cumbrian drystone wall.

6 Orange lichen-covered rock supporting a circular grass green cushion of lichen in Pembroke.

7 Lichen on mottled roof tiles in Dubrovnik, Croatia.

8 A flash of bright yellow lichen against wet black rocks on a Devon beach.

9 Black lichens on monoliths around Avebury.

Overleaf

10 Multicoloured lichens on a monolith at Avebury.

11 Yellow lichen on a monolith at Avebury.

12 Close up of lichens on Avebury stones.

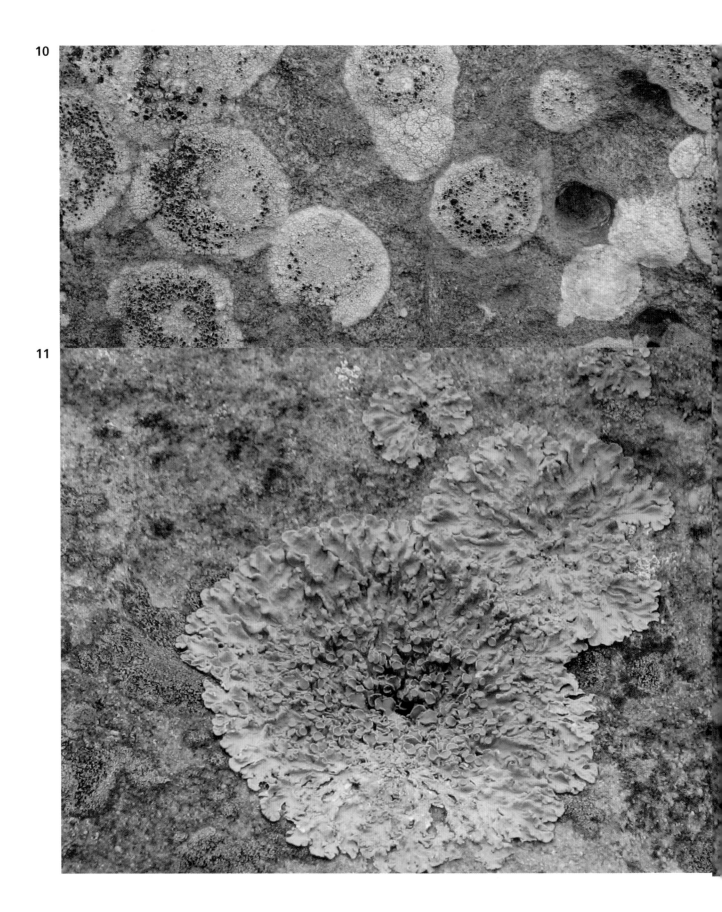

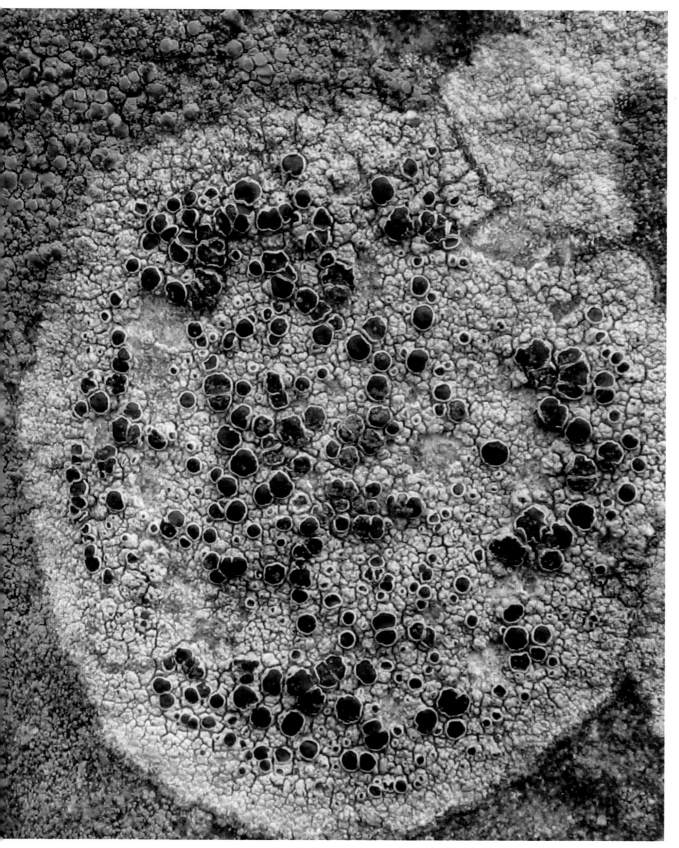

13

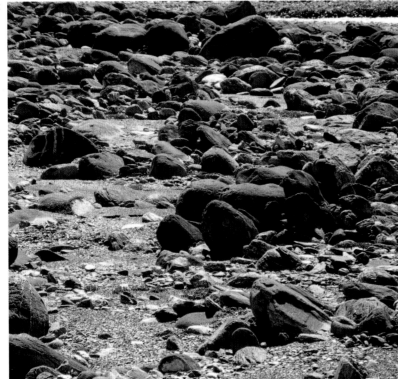

15

13 Grey rocks covered in fiery-red lichen in a dried riverbed near the Franz Josef Glacier in New Zealand.

14 Near Franz Josef again. Grey rocks covered in vermilion-red lichen.

15 Rocks with white stripes, enhancing pattern and texture.

16 Emerald-green moss creeping up the lichen.

(Overleaf)

17 Green lichen found in an Epsom garden in Surrey.

18 Bright yellow lichen on a Dartmoor rock, Devon.

19 Lichens of different colours growing in a triangular pattern at Avebury.

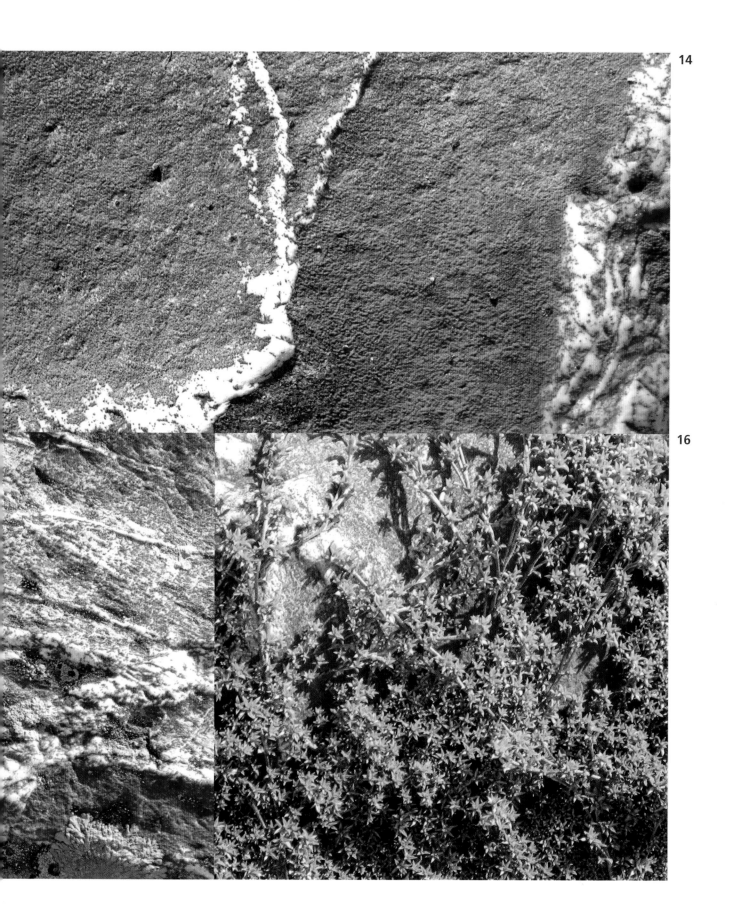

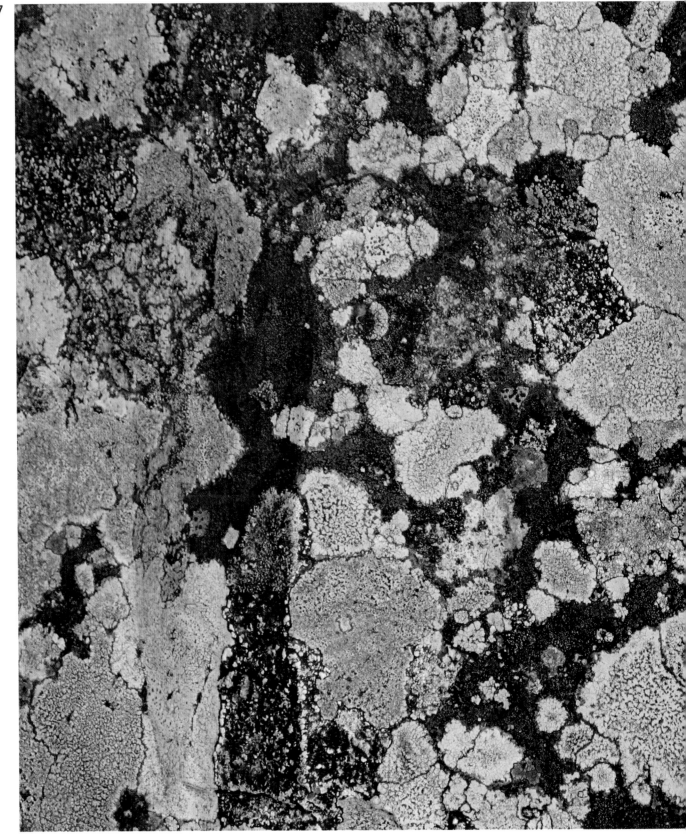

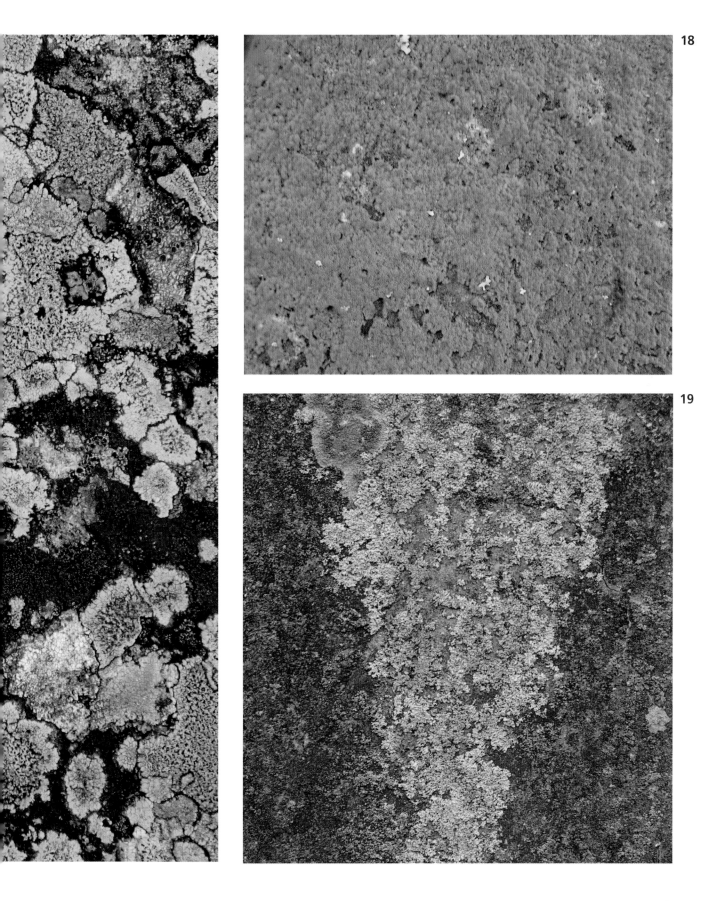

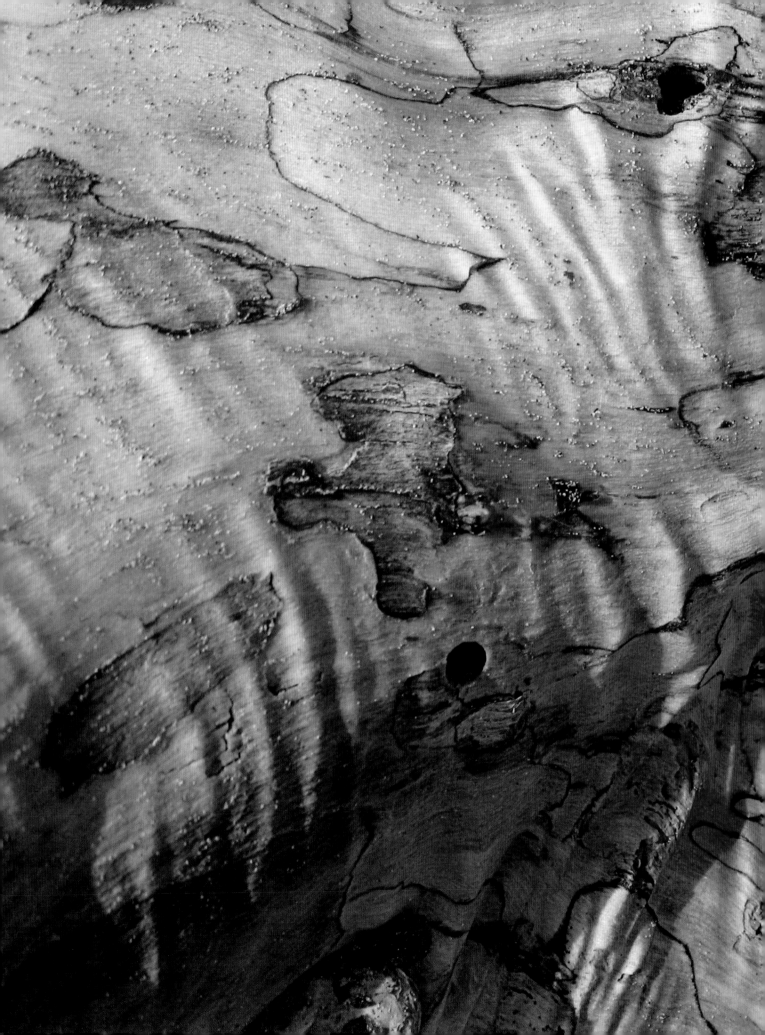

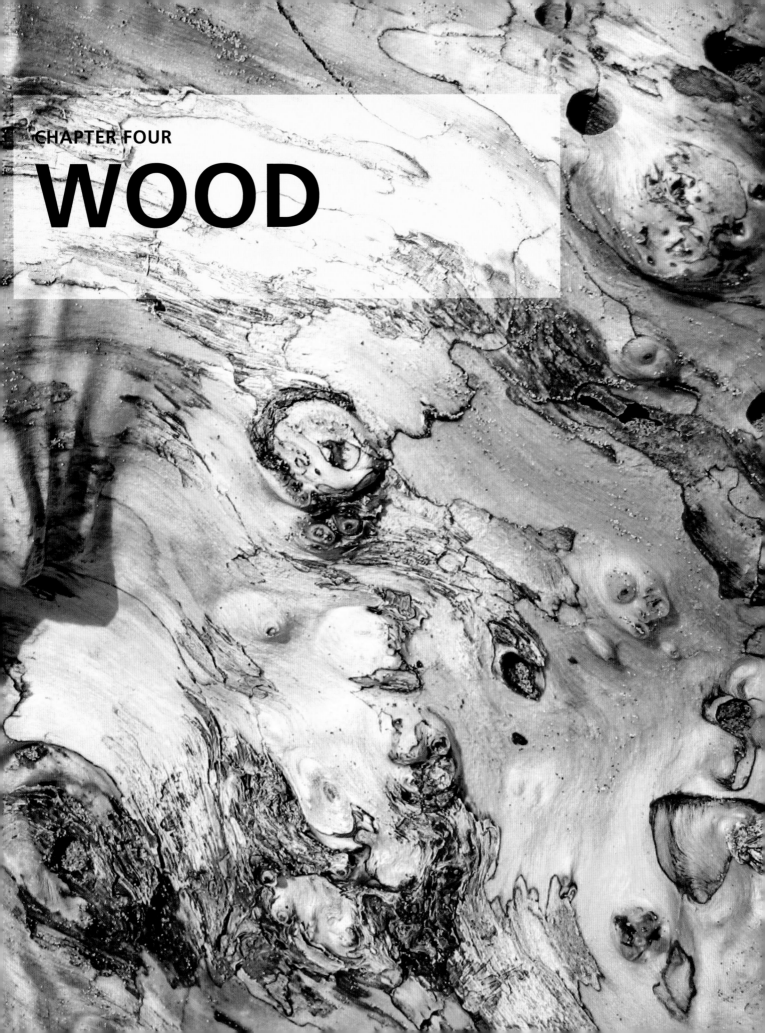

WOOD

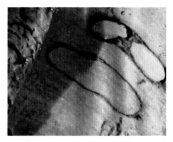

B ark is a tree's living armour, protecting it against infection and attack. It is like the epidermis on the human skin, protecting all that lies within. Bark is also a home to an eco-system of insect and fungal life, living harmoniously for the most part on its surface, each organism doing an environmental service for another in an inter-dependent mesh of life.

The bark of a tree differs from species to species and can help us identify a particular type of tree. However, bark is so much more than simply a method of identification or the external skin of the tree. It is so easy to take these wonderful organisms for granted. Should we care to look, we can see a wide range of organic ornamentation, colours and textures. These surfaces can offer peeling, paper-thin layers or crustily thick skins, covered in whorls, striations, pits, ruts and camouflage patterns with a kaleidoscope of different formations, sometimes resembling low-relief sculptures.

Each individual tree, covered in skin and scars, possesses an indelible record of the time in which it has existed, with its own history engraved into it like a code.

The textures, marks and hues of bark give clues as to the species of that particular tree, and are as unique as the colours in human eyes. Perhaps the sight of particularly interesting bark makes you, too, feel the need to touch it, to run your fingers over it and enjoy its textural surface. It certainly has that effect on me.

Some surfaces, such as those on the bark of a silver birch, can be covered in patterns that might easily fool the eye into thinking they are the work of a human hand. I was almost convinced that one tree I came across had delicate pictures of mountain ranges drawn onto the surface with a fine pen.

I particularly loved the paper-bark maples I came across in Greenwich Village, New York. They shed their cinnamon and honey-coloured bark in crispy, tissue-paper-like curls, looking for all the world like sloughed snakeskin.

Wood can also be enjoyed in its many different inanimate forms. Driftwood can take on a soft grey ghost-like look, washed by the waves, bleached by the sun and rounded by the wind. Ancient, silvered fence-

panelling, scoured by weather and time, has its grain raised and exposed to resemble a fingerprint.

Two of my favourite images are the close-ups of incinerated, burning wood used as fuel to fire a pottery kiln in Wales. In one, although heat has turned the wood white, the glowing red embers can still be seen deep within the crevices. You can almost feel the temperature. The second shot, taken in another area of the same kiln, shows the wood from a different angle – the intense heat has given it a friable appearance, though to me it resembles magnified hair shafts. From the ashes of one image, phoenix-like, another rises.

A timber yard in Surrey gave me the stacked wood images. Multiples of anything tend to be eye-catching, and in these photographs produce unexpected patterns and shapes. Sunshine illuminates the wood and also casts shadows, giving darker emphasis to some areas. Look at the photograph showing the square stacked timber, and follow the differing paths along which the end-cut semi-circular grain patterns lead the eye, never quite achieving the perfect circle of the precut wood.

For me, wood is a most wonderful, versatile, plastic and fascinating material – a sustainer of life and a small organic miracle deserving recognition in all its incarnations. Take time to admire it in its many forms. I hope that these images will encourage you to become more aware of the communal legacy we all hold in trust, which is also there to be seen and enjoyed.

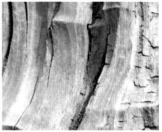
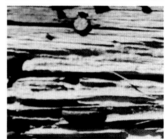

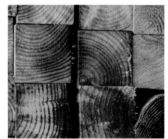
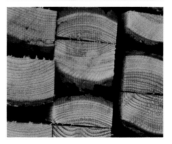

1 *(Previous double page) Driftwood from Foxton Beach, New Zealand.*

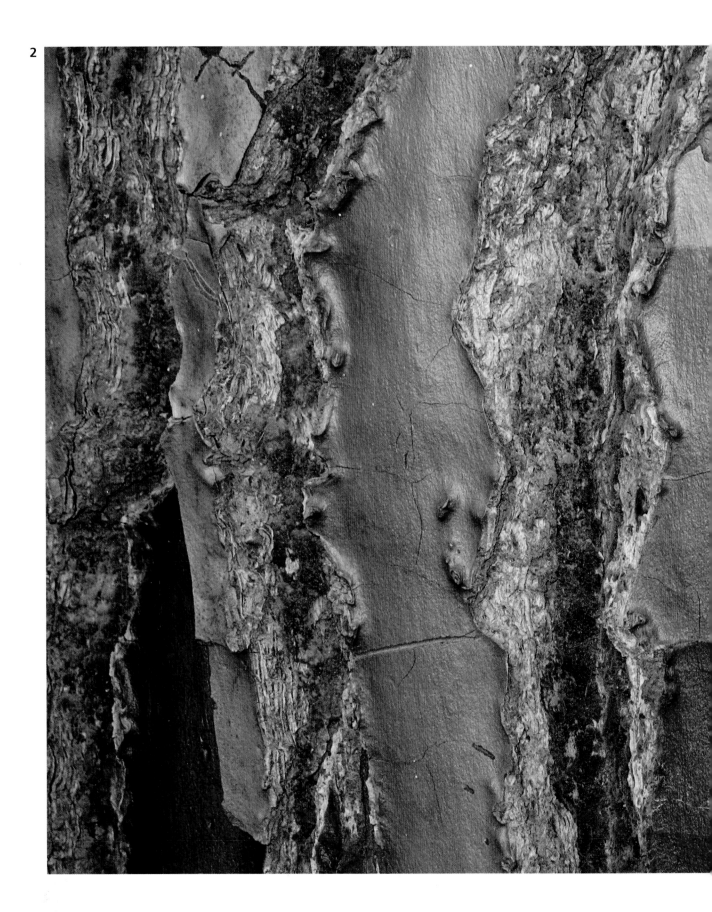

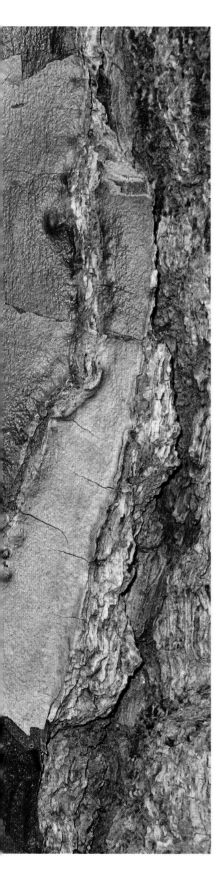

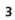

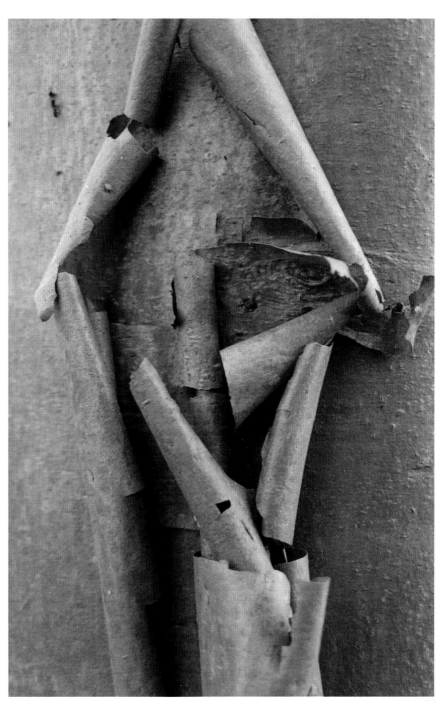

2 Tree bark in Wai-O-Tapu, New Zealand.
3 A detail of the paperbark maple tree.

4

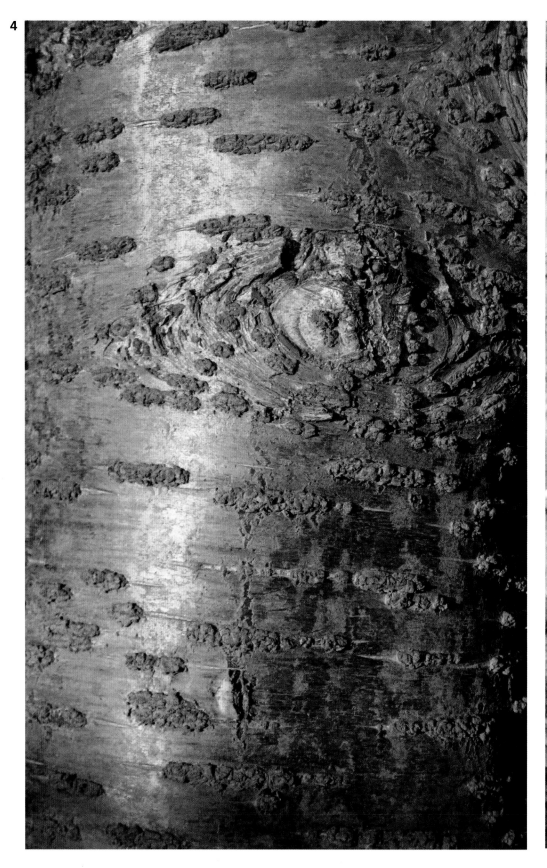
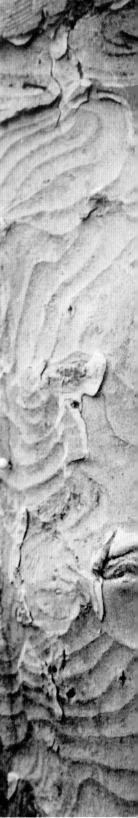

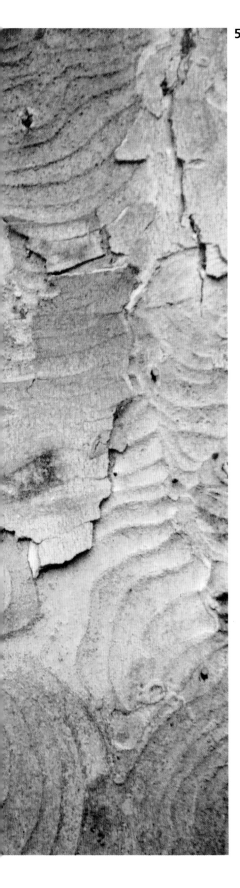

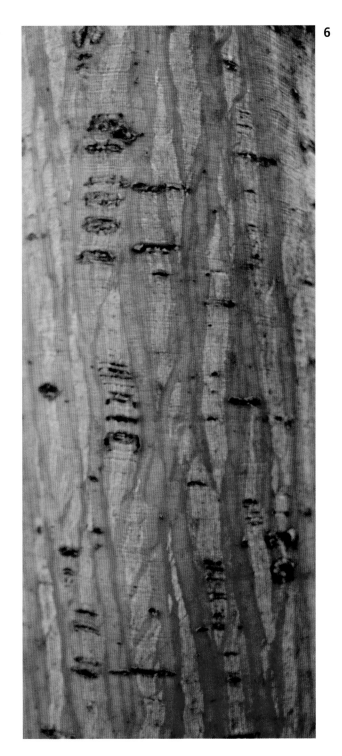

4 Golden-hued bark.

5 Undulating, serpentine whorls on bark in Surrey. Note the emerging patterns on the newly growing surface.

6 Coral bark maple found in Surrey.

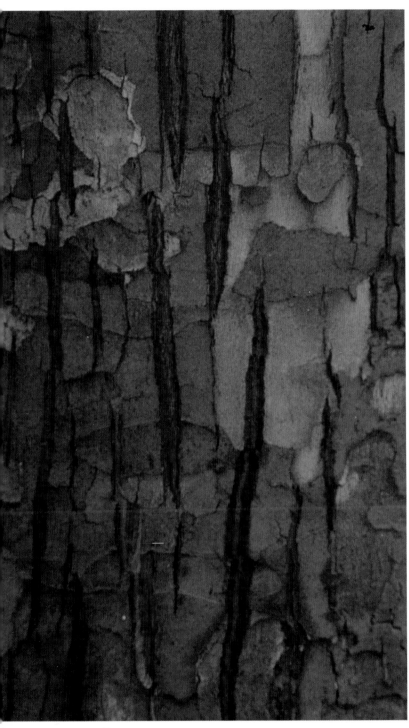

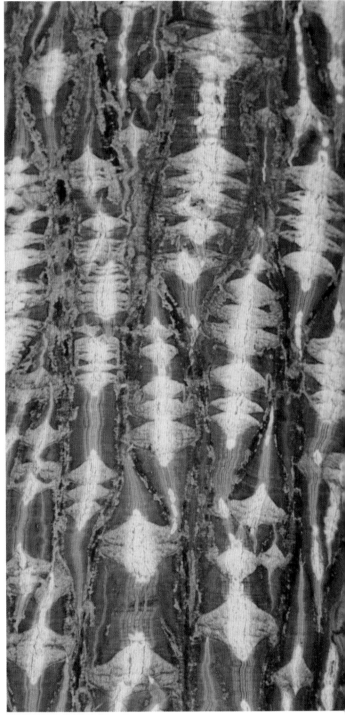

7

8

7 Cracked and split growth marks on moss-coloured green bark in France.

8 Shiny snakeskin-like tree bark from Madrid.

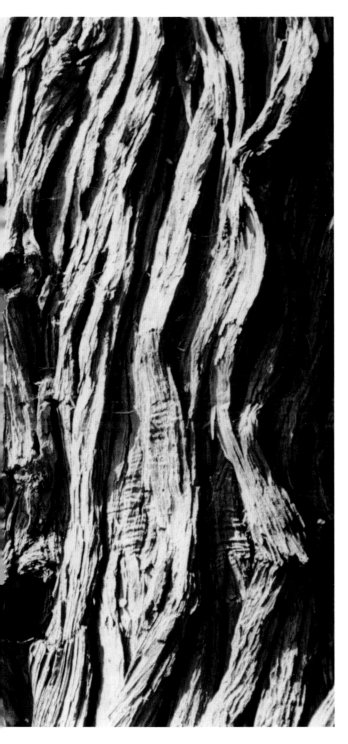

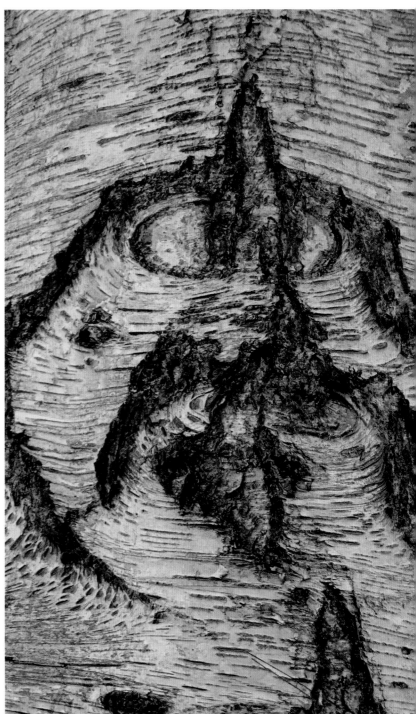

10

9 Deeply furrowed and rugged bark from France.

10 A silver birch tree with 'mountain range'-type markings.

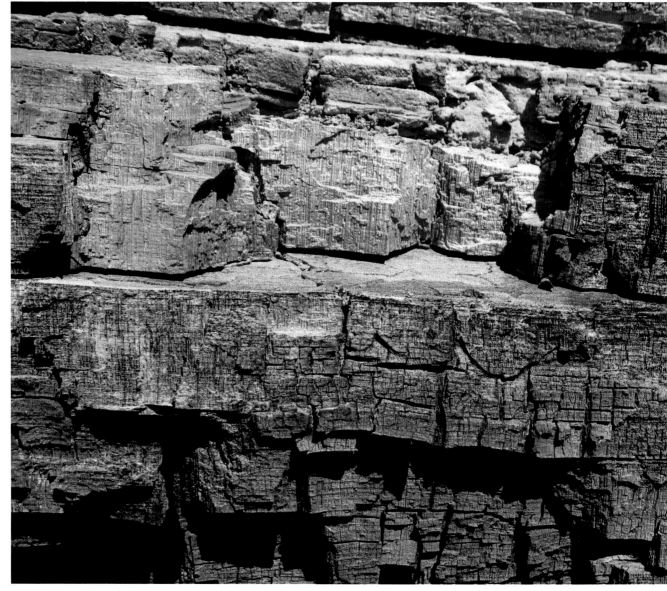

11 Dead log found near Waiweri, Wangapora Bay, New Zealand.

12 Rippling, curved driftwood bleached a silvery-grey, from North Island, New Zealand.

13 Part of a faded farm fence panel in Croatia, its grain raised by weather erosion and age.

(On next double page)
14 & 15 Burning wood used to fire a Welsh pottery kiln.

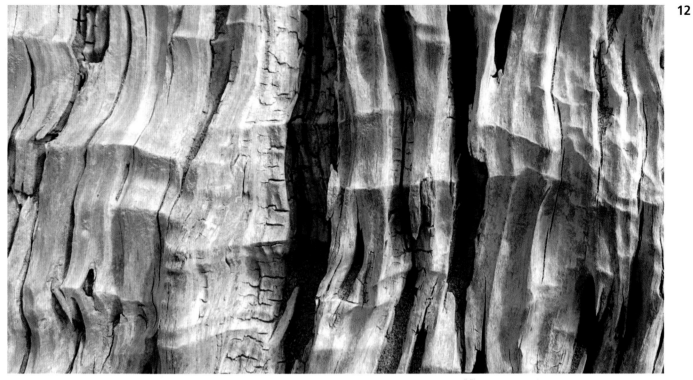

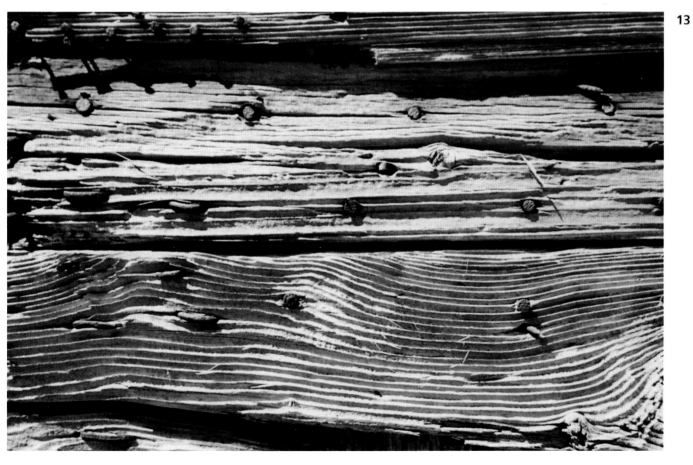

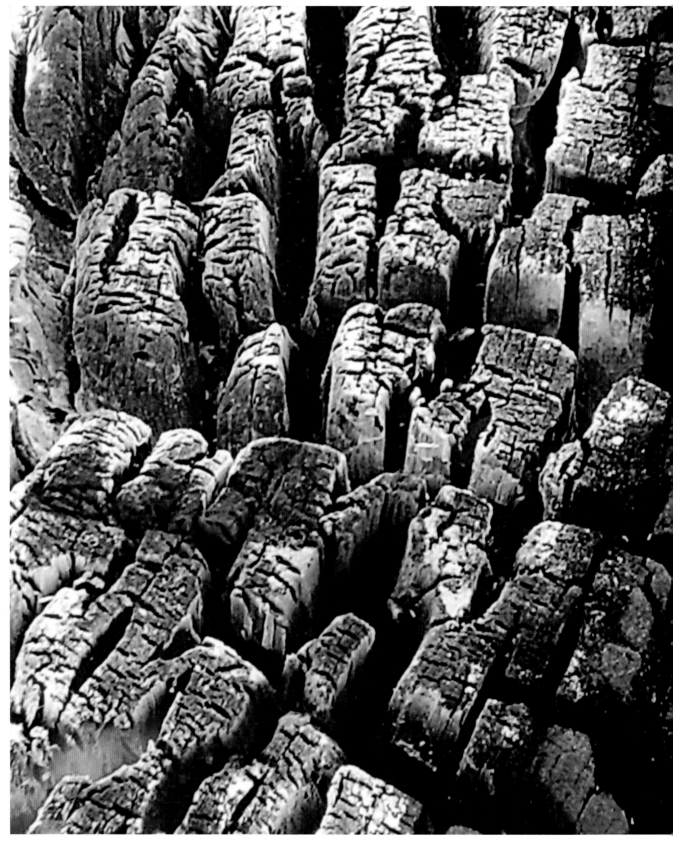

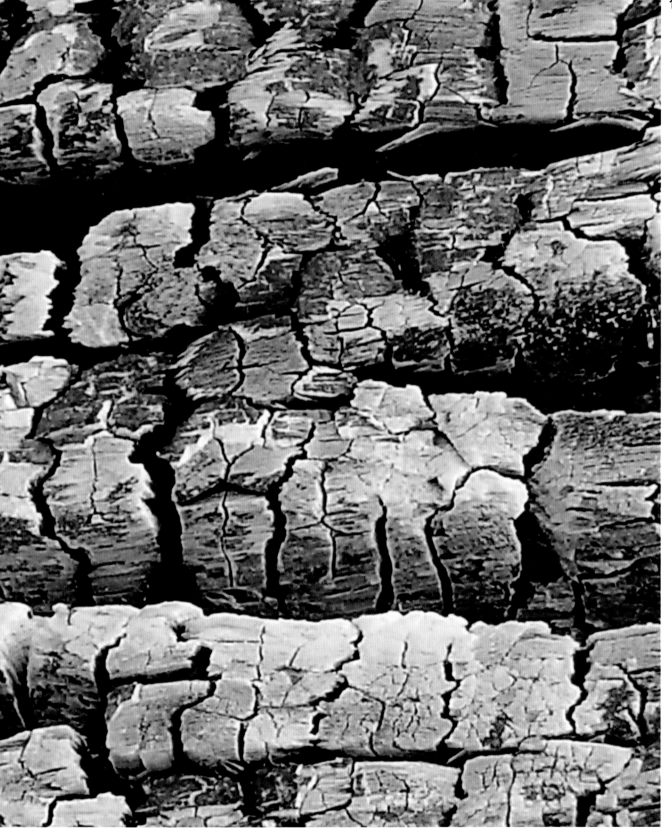

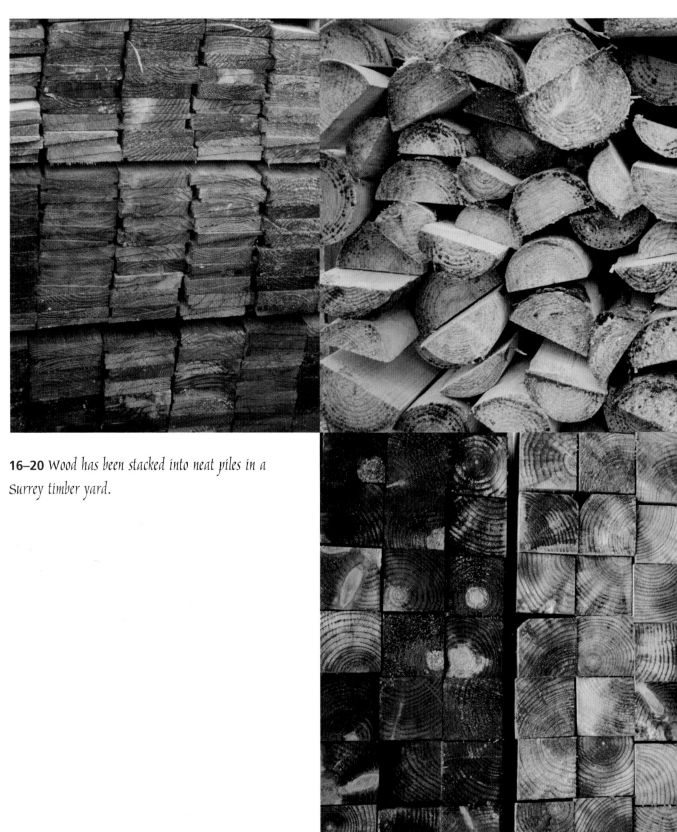

16–20 Wood has been stacked into neat piles in a Surrey timber yard.

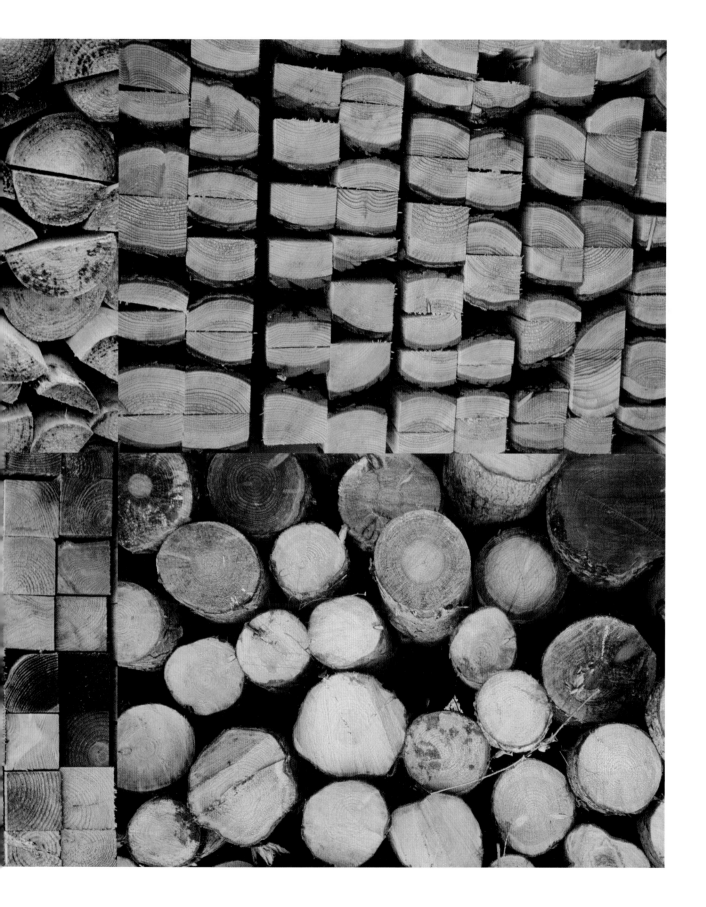

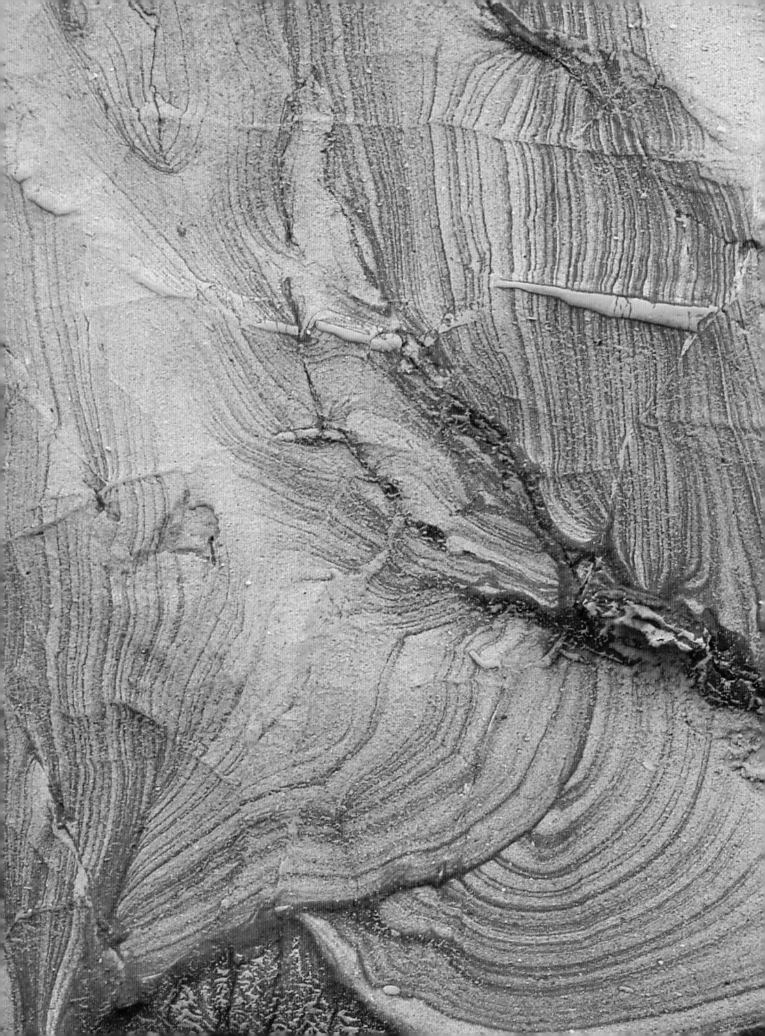

WALLS

First, a definition: a vertical edifice usually taller and longer than its breadth, used to enclose, support or divide space.

I feel justified in including maritime rock faces alongside the constructions that we normally recognise as external and internal walls. I use the term 'wall' loosely. Surely they support and enclose the earth within, dividing the countryside from the beach and the sea, much as other walls might enclose, support or divide domestic or external space?

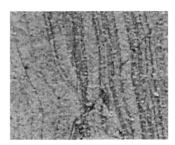

Cliff faces, determined by the composition, chemistry and geological structure of the rock, shaped by time, prevailing winds and abrasive salt spray, present a rugged and deceptively unyielding face to the world. Their colour is derived from the composite minerals contained within that geological area, be they iron oxide, manganese or limonite, among many others.

Amber and toffee-colour swirls along with layers of hard sand form striped patterns and curves across the front of one cliff face found in Wangapora Bay in New Zealand. Darker veins streak through the sandstone surface creating rich seams of colour, changing the direction of the stripes and giving a marbled and agate-like effect.

One cliff face, also in New Zealand, has been so eroded by the sea that the softer stratus of the rock has been worn away, leaving rounded edges and deep furrows. The action of the tide has caught pebbles and shingle and flung them into grooves, wedging them tightly, creating a natural low-relief sculpture.

Layers of hard rock on one Devon cliff face might offer a climbing wall to those with the mind to attempt it. The black rocks may be imposing but the way they are composed suggests ledges meant for clambering up.

I love the majesty of these magnificent natural structures viewed close up, exhibiting intriguing patterns and glimpses into an ancient world. They make me want to know more about geology, though of course they can still be enjoyed at face value.

Walls generally provide a canvas for any number of textures and colours. A stone wall in Pons, France was filled with red mortar – whether it was lichen or dyed cement, I could not tell you, although lichen had grown over the damp stones on a similar wall in Lisbon, turning some of them bright-green.

Another drystone wall in the Lake District of Cumbria was alive with green moss, which was interwoven and ornamented with flashes of the bright, marigold-coloured lichen that also grew on the rounded grey rocks.

I have already mentioned that graffiti generally does not excite me – it is too deliberate for my taste. However, in a tunnel walkway along one of the paths of the Cinque Terre National Park in Italy, I saw parts of a graffiti-covered wall that made me reconsider my preconceptions. It was covered in bright, angular, abstract shapes and patterns such as the purple and blue section on pp.76–7.

Inadequate surface preparation and dampness seeping through the earth and in the air was the probable cause of the white paint slowly wearing away from the retaining garden wall in Surrey. The paint was gradually blistering and rubbing off, revealing the red brickwork underneath. Emerald-green moss was starting to colonise it, adding to the variegations of colour.

Equally, internal walls can provide rich pickings when it comes to fabulous surface textures: old plaster that has cracked and is vitalised with coloured mould and powdery mildew; walls with time-worn crazed paint peeling away; empty ghost marks showing where bottles or preserves have stood against ageing plaster walls in an old larder – a glimpse into another time.

One unpainted, mouldering plaster wall found behind some wooden panelling and superimposed with grey and brown dirt, smudges and scratches, had a misty, cloudy, impressionistic look to it, and reminded me of one of Turner's paintings.

Frequently, countries such as Greece or Italy, where the light is strong, are where you will find bright peeling paint on external walls; dilapidated walls, perhaps, where paint has been worn away, carelessly reapplied in some areas, and further time-deteriorated, giving a layered effect compounded by mysterious scratch or dent marks.

Green mildew had grown on powdery, crumbling white paint on a wall in a damp, shady Venetian alleyway. The underlying wall had evolved into a russet-brown/black, creating a variety of textures and colours and a sense of spectacular decay.

It is not surprising that we take most walls for granted; we pass them every day without a second glance. Many are ordinary, and though they may also be worthy of some level of contemplation, those that will eventually seduce us will have been made to come alive because of time or weather permeating and eroding the surface. We just have to learn to see them with an artist's eye.

Be alive to the potential in walls – they are all around you.

1 (*Previous double page*) *Swirls and curves on a sandstone cliff face in Waiweri, Wangapora Bay.*

2

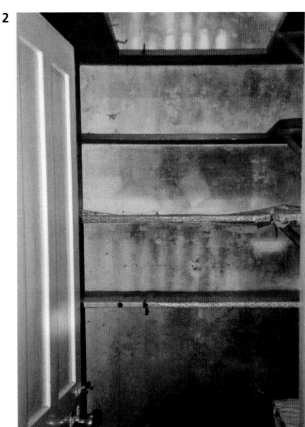
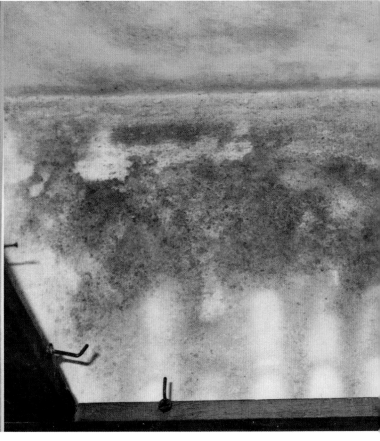

2–3 A larder wall in Surrey showing ghost marks from long-gone jars of preserves.

4 A begrimed plaster wall found under panelling.

5 Splattered paint on the exterior wall of a small rural house in Navplion, Greece.

6 Marks on a wall on the side of a small house down an alleyway in Vivari, Greece.

7 Concrete splashes against the wall of a Greek taverna undergoing restoration.

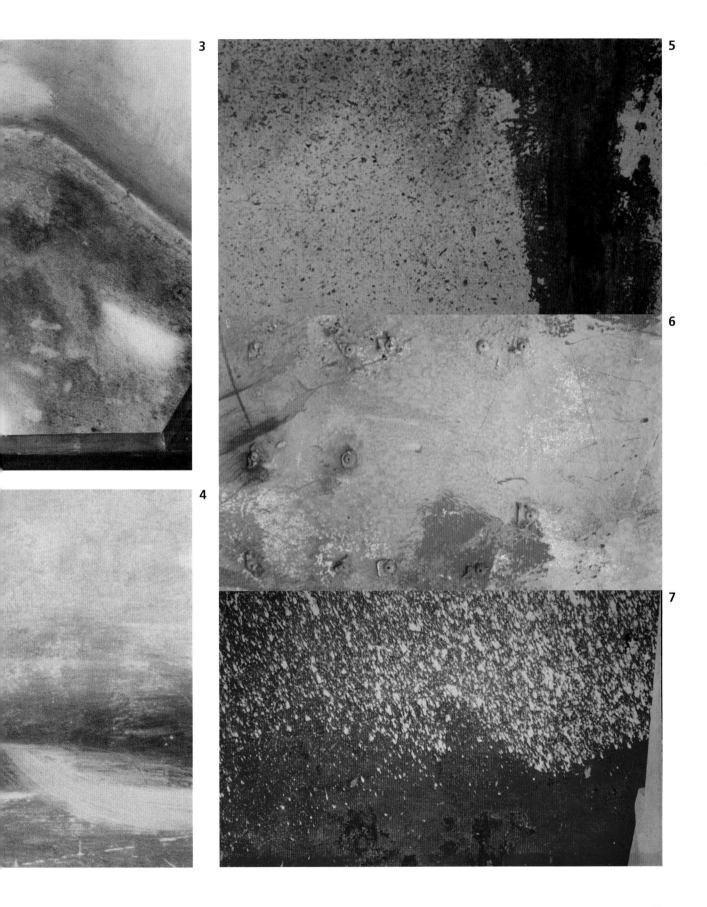

3

5

6

4

7

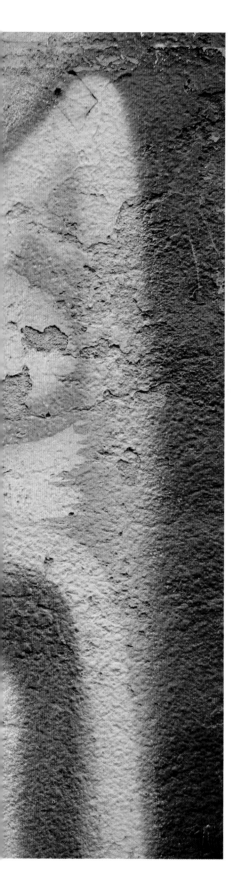

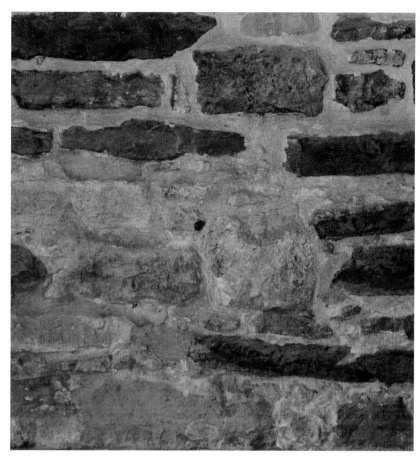

8 *Part of a wall in the Cinque-Terre National Park, Italy.*

9 *Green mildew on stones in a wall in Lisbon.*

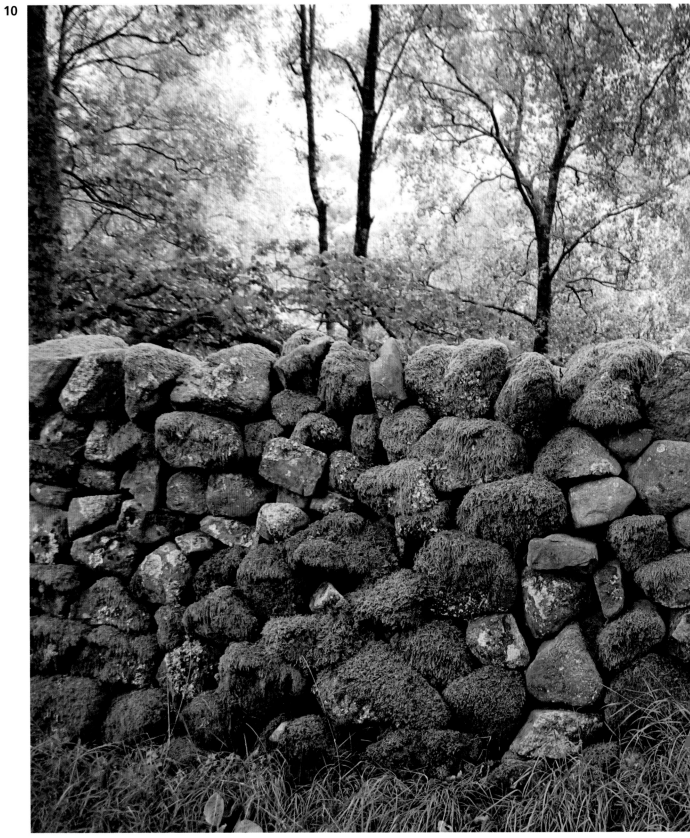

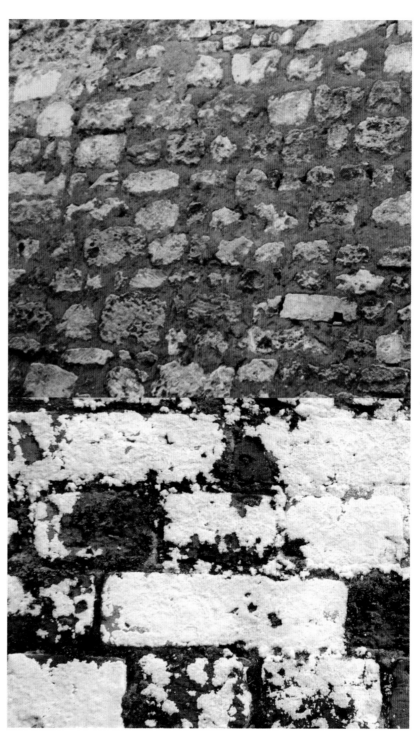

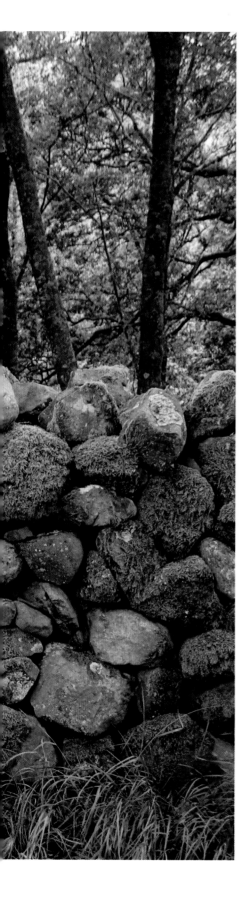

10 A drystone wall in Cumbria.

11 A wall in Pons, France with orange-red mortar.

12 This Surrey garden wall is part-painted, part-revealed brickwork and part moss.

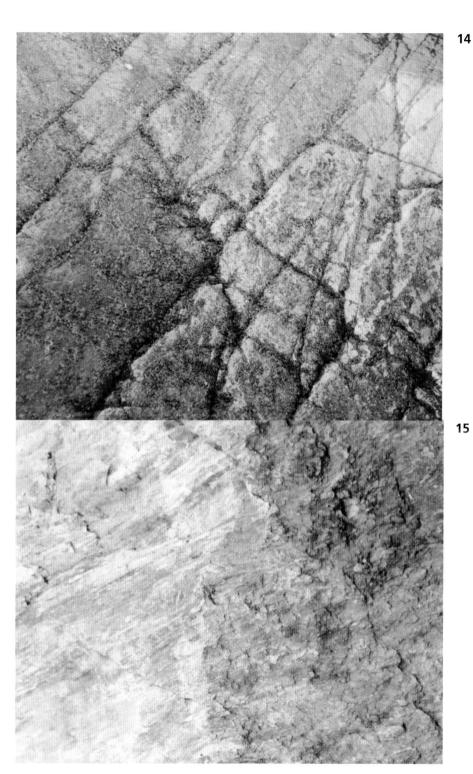

13 Mildew on a dilapidated wall in Venice.

14 Rock face resembling magnified human skin in Devon.

15 Red iron oxides colour this cliff face in Pembroke, Wales.

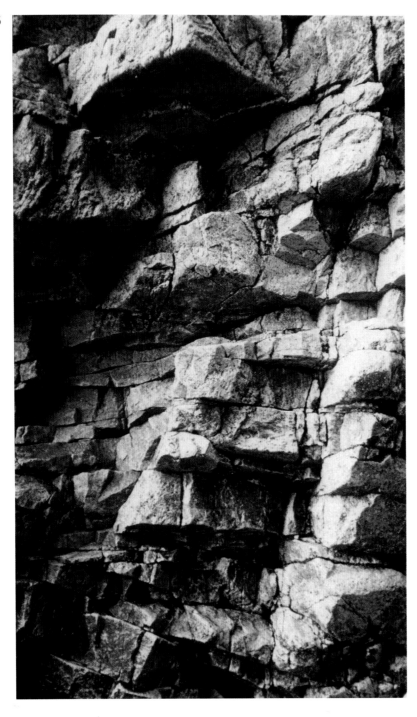

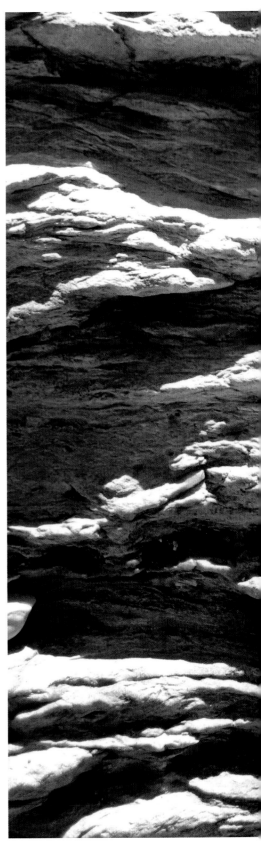

16 *Layers of rock strata in Devon.*

17 *Tidal activity has eroded rock and wedged pebbles in the cracks on this New Zealand cliff.*

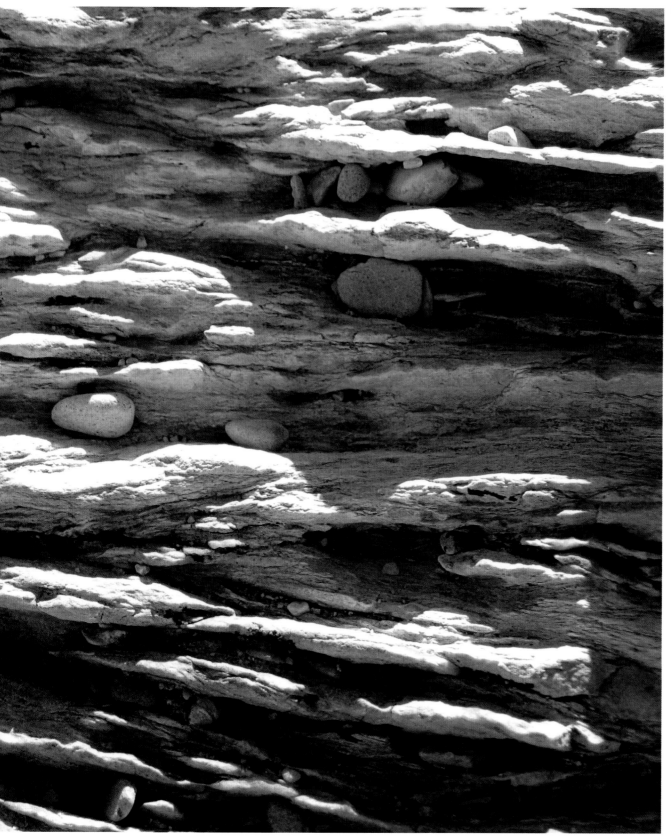

CHAPTER SIX

GROUND

We tend to go about our business, our attention restricted to our eyeline, not considering the surface that supports us. We might think about the ground for safety's sake if, for example, we are walking on rutted, uneven areas, but on the whole this is not what captures our attention. The ground is merely the medium upon which we move. We do not normally give it much thought.

When discussing the ground, I am not referring to any of the spectacular and beautiful landscapes seen the world over, but more mundane surfaces perhaps organically evolved or covered in manmade materials. I think it is a case of homing in on what we neglect under our noses – or, rather, our feet.

Digging in the earth with a small JCB revealed a rusty-orange slice of terracotta pipe used as part of a Victorian land drain. Finding the small coloured circle amongst the green sandstone and overlying clay felt like discovering buried treasure.

I loved the large, white, partly broken circle found in a car park in Rochester, Kent. Could it be the overspill of unknown substances from an upturned drum? Could it have been randomly painted? How can we know? Part of the fascination is in finding a seemingly spontaneous mark which has weathered into its surroundings. It has also been wonderfully eroded by the number of cars that must have driven over it. If it had been deliberately, carefully and newly painted, it would not have had the same value for me.

Sometimes it is difficult to know why an image draws you in. The New York iron drain cover is battered and worn by all the feet and cars thundering over it. The surface colour is gradually being worn away by all the activity wrought upon it. Pools of colour remain within the rubbed-away surface, giving a scratched textural appearance, though that too may be partly due to its manufacture.

The ground at Wai-O-Tapu, Rotorua, in New Zealand, was more spectacular in grabbing the attention. In some areas, around the thermal springs, deckled edges of earth have been worn away by the weather, revealing multiple tones of yellow-ochre earth. Another image shows bright patches of crumbly copper-oxide-coloured earth. The third shows a combination of the two.

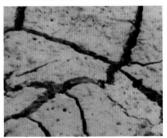

I have included a close-up of the Terraces at Wai-O-Tapu, which were covered in very shallow water. Made from mineral deposits, these have built up over time, making decorative and delicate layers of pattern resembling a contour map.

On a beach near Eastbourne, East Sussex, I came across a series of wooden railway sleepers forming a makeshift path. They were sandwiched between a stripe of green foliage, freckled with pebbles and capped with a bright splash of lichen.

Looking at surfaces on the ground can highlight the way nature repeats itself. Compare the dried mussel bed near Carnac in France, the cracked clay slip found on the floor of the pottery studio in Rochester, and the soft mud formations found at Wai-O-Tapu, Rotorua. Although different in scale, the patterning of the cracks was roughly the same – Nature's geometry.

I love the mass of tractor-tyre marks made in the thick muddy ground found in a timber yard in Outwood, Surrey. They criss-cross over each other, acting as reservoirs for rainwater, making a network of shallow trenches and giving hints of the activity that has busily taken place there.

Ignored and unnoticed by most of us, the ground beneath our feet can harbour many sights, shapes and colours. Once you start looking down at the ground with eyes wide open, you will notice, quite literally, a whole new world opening up beneath your feet.

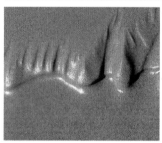

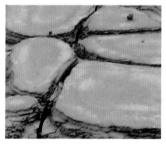

1 (*Previous double page*) *Part of a scratched and battered New York drain cover.*

2

3

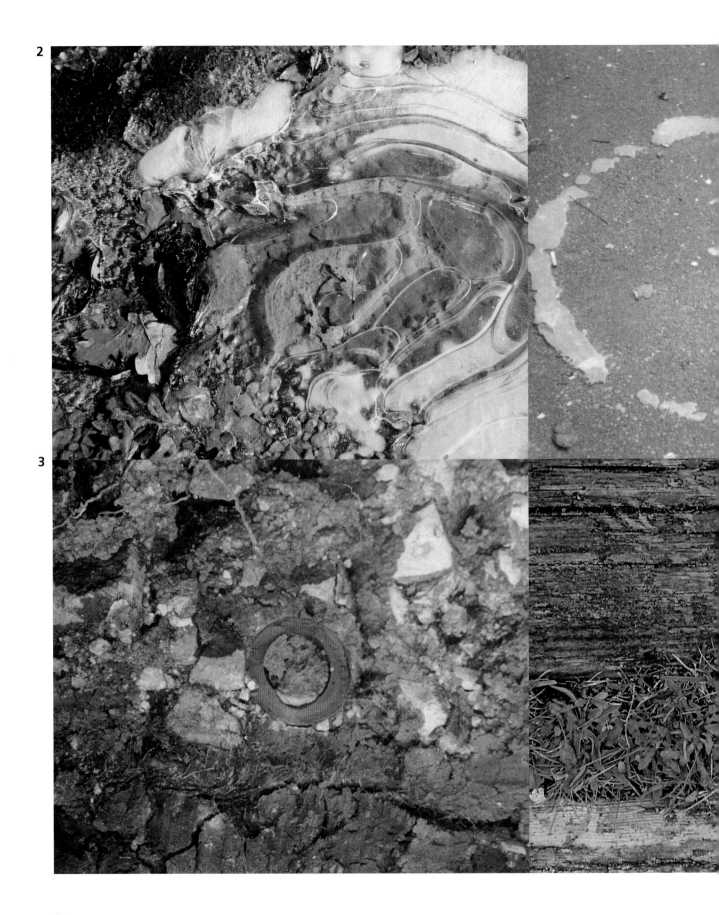

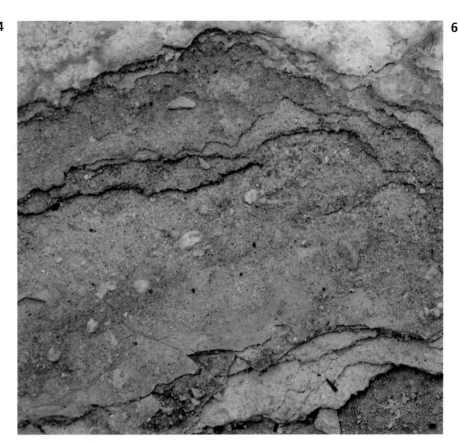

2 A puddle of curved, crazed ice cracks.

3 A Victorian terracotta land drain chopped in half, found whilst digging through clay.

4 An eroded imperfect circle discovered at Rochester, Kent.

5 Lichen-covered railway sleepers, against a stripe of green foliage and a scattering of pebbles, alongside a Sussex beach.

6 Sulphuric-yellow speckled and layered ground in the Wai-O-Tapu thermal springs in New Zealand.

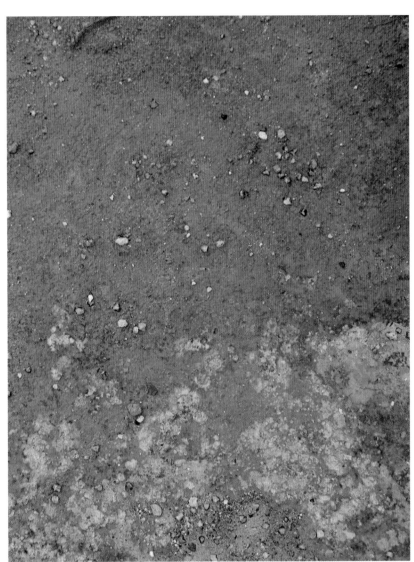

7 *Again, Wai-O-Tapu thermal springs. Oxide-rich copper-coloured earth.*

8 *A combination of colours and textures at Wai-O-Tapu.*

9

11

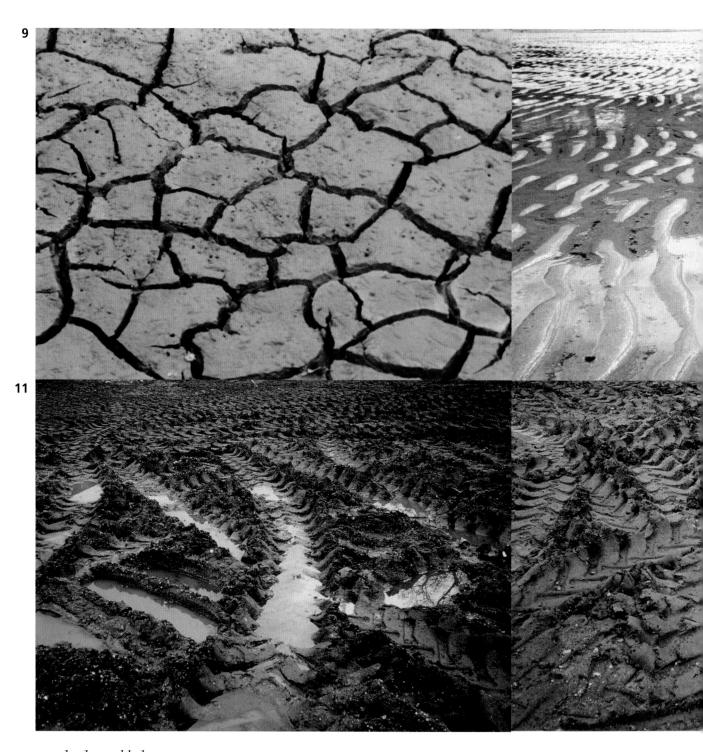

9 A dried mussel bed near Carnac in France.

10 Light catching puddles of water caught in sea-patterned sand near Salcombe in Devon. Note the sense of perspective.

11 Water caught in furrowed tyre marks found in deep mud near Outwood, Surrey.

12 Criss-crossing tyre tracks, again in Outwood, Surrey.

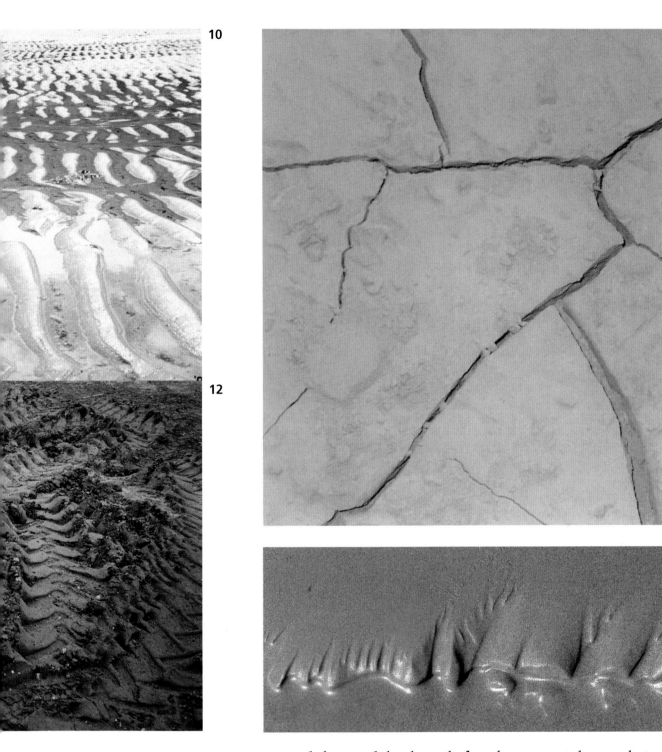

13 Dried, fragmented clay slip on the floor of a ceramics studio in Rochester, Kent.

14 Marks on the sand on the Otago Peninsula, New Zealand.

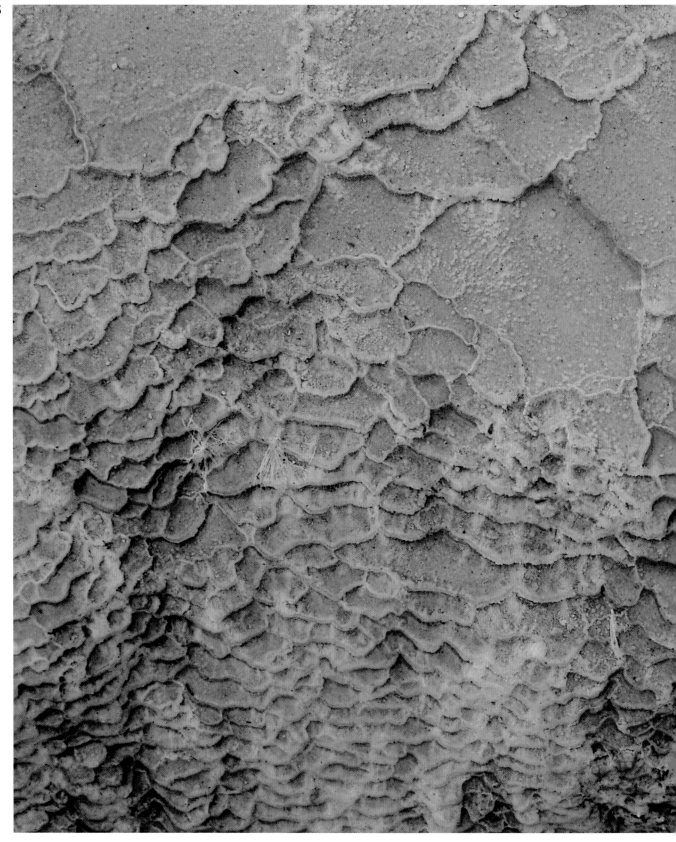

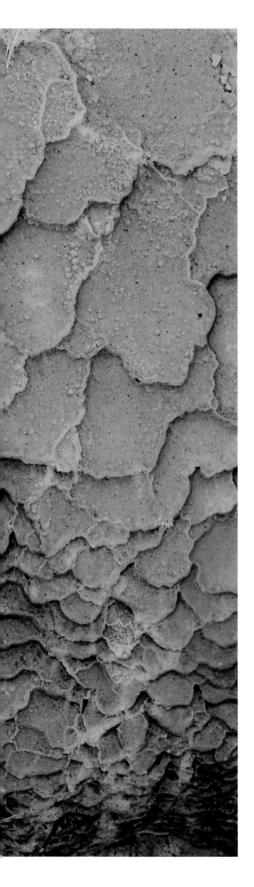

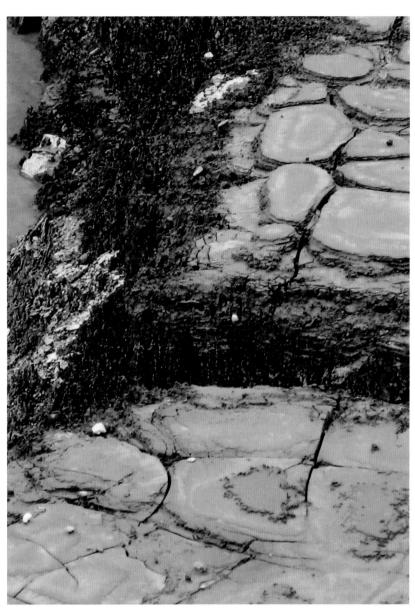

15 *Mineral deposits formed these delicate patterns on the terraces in Wai-O-Tapu.*

16 *Soft mud formations seen at Wai-O-Tapu.*

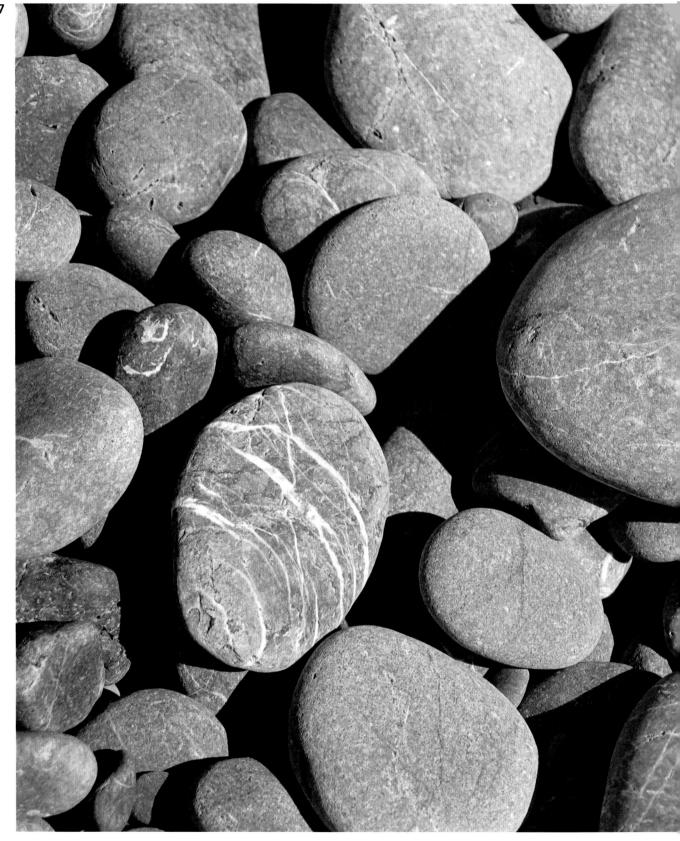

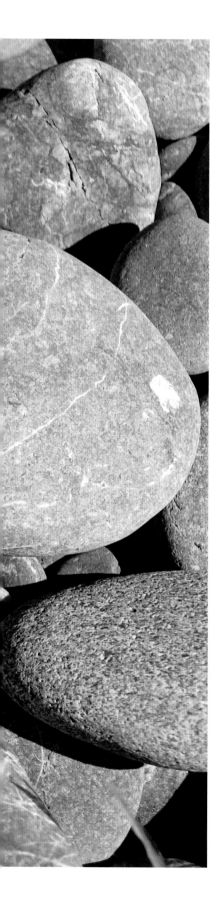

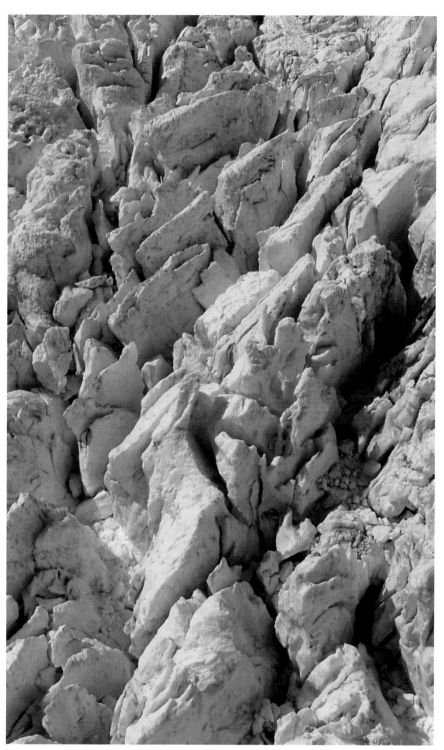

17 Dove-grey striped pebbles from the beach at Kaikoura, New Zealand.

18 An aerial view of the choppily textured, icy landscape of the Franz Josef Glacier, New Zealand. Note the glimpses of blue within the ice fissures.

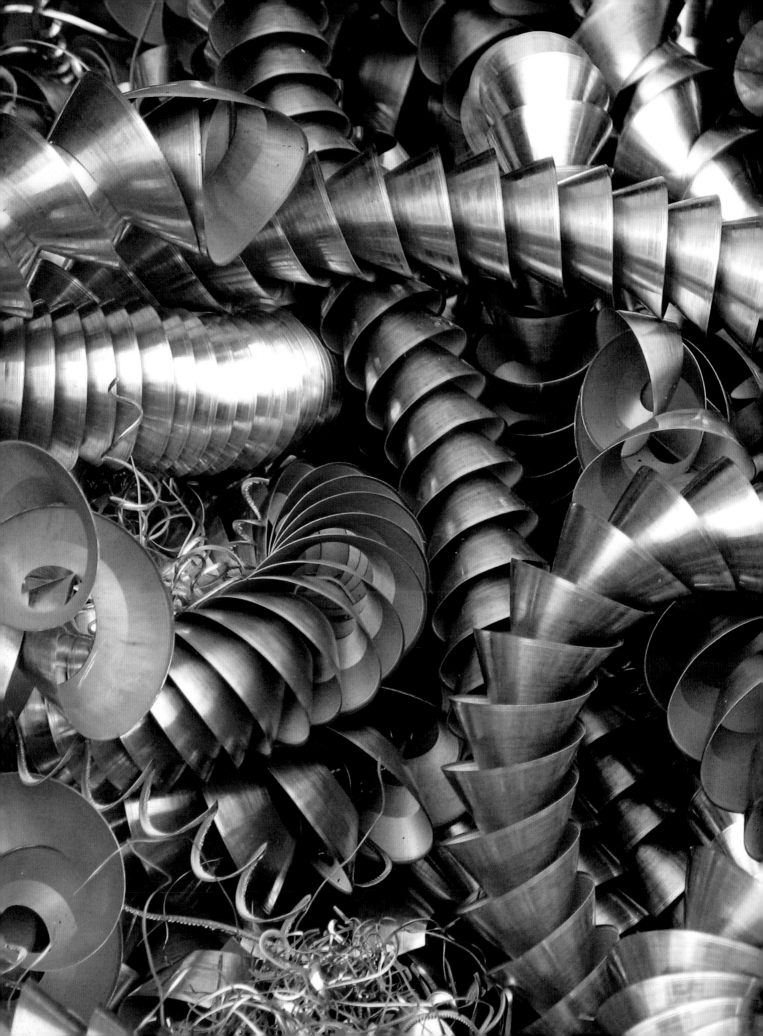

FOUND OBJECTS & MARKS

An unexpected splash of white is hidden under a stairwell where someone has cleaned the surplus paint from a decorator's brush. Engraved, purposeful, curved knife slashes on a leatherworker's bench; strong, bold graphic daubs of paint against the base of a lamppost in Central Park in New York.

I am intrigued by the codes left on underground walls from one workman to another – instructions, probably, but what was the intention behind them? Is it a secret language or jargon between workers, indecipherable to those outside the trade?

I love the mystery and energy of these marks, the sense that a story could be attached, and I enjoy not knowing for certain what these could mean; it does not seem necessary to know. I just like the shapes, colours and composition.

Some can be difficult to categorise, they are so random and disparate. Whatever it is, they have caught my attention simply by being strangely beautiful, and I do not always understand why I should find them so, no matter how hard I try to analyse. I can never predict where I will come across these interesting marks, so the image has to be captured when found. Marks such as these are frequently not deliberately made but have sometimes evolved organically, often simply as a by-product of human actions.

I am not especially attracted to the graffiti that can be seen adorning the sides of trains and buildings – I find it too intentionally made and too formulaic. I know that such graffiti does have its devotees, but I am not one of them – it appears too self-conscious for my taste. I find accidental marks or textures more intriguing.

Despite this admission, whilst walking through London, I did stumble upon one piece of graffiti I found interesting. It resembled an infant's scribble-writing, especially as the purple paint used had dripped down the wall, adding an accidental element to the piece. There were no words, as such, that I could recognise, but it looked as though there could have been, as the lines were visually fluid – almost calligraphic.

The marks that fascinate me are frequently casual and unintended. The maker may not even have realised that they have made them. Examples such the urine-stained bathroom wallpaper around a toilet,

splashed and unknowingly ornamented by a houseful of sons; wood that has had painted words sprayed on the side but has then been reshuffled, making a nonsense of the writing; and marks made on the side of a garage wall by children drawing with the charred ends of wood from a bonfire.

Hand-cleaning from printing ink produced the vivid magenta stains in a porcelain sink in an art studio. Note, too, the bright splashes and blots of paint dripped and flung onto the floor during the creation of more deliberate works of art. These by-products of student work have as much value for me as the work itself.

Walking across Brooklyn Bridge in New York, my attention was drawn to the road marking. New white paint had been applied on top of the old yellow paint, leaving a narrow framing strip on either side. Charcoal-grey rubber stripes from bicycle tyres scored this white paint whilst leaving the main surface clear, and there was one single embedded footprint which I found irresistibly attractive.

However much I try to analyse why we can be drawn to these marks, I draw a blank. Is it purely an aesthetic attraction? I would have to say no. Is it the apparent randomness? To some extent. Is it the forensic detective in us who wants to piece the clues together and unravel the events that previously took place? Perhaps. Could it be the delight in discovering something that perhaps many onlookers have not noticed? Yes, it could be …

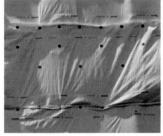

Really, it could be a combination of all these reasons and more. Even if you do not understand why, once you start to see these marks all around you, the world becomes a much more richly textured and intriguing place.

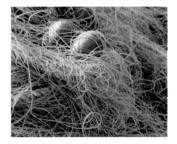

1 *(Previous double page) Swarf – metal remains left after the machining of aluminium.*

2

3

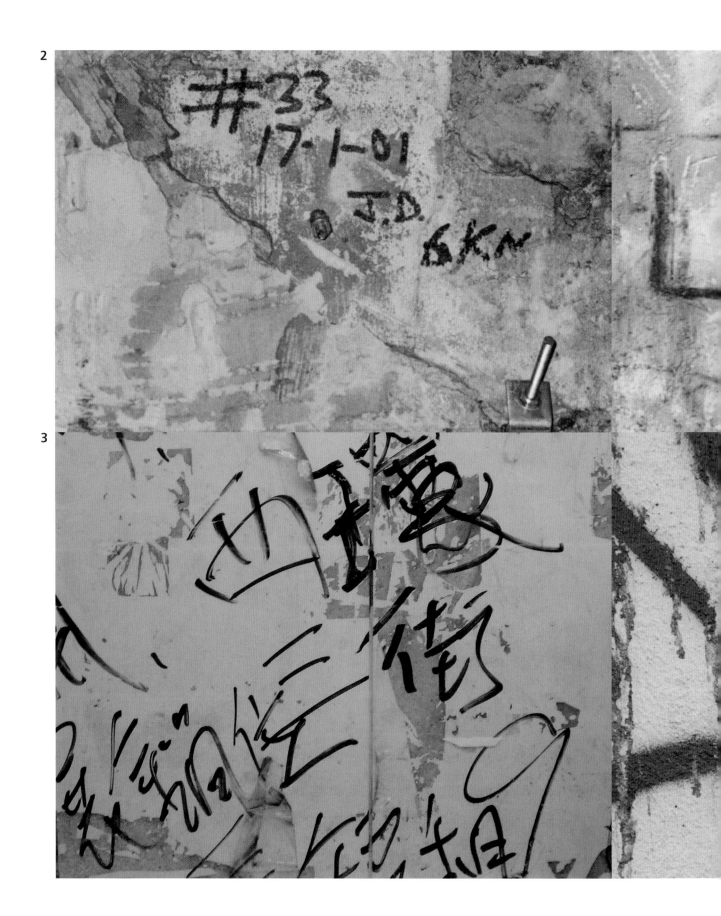

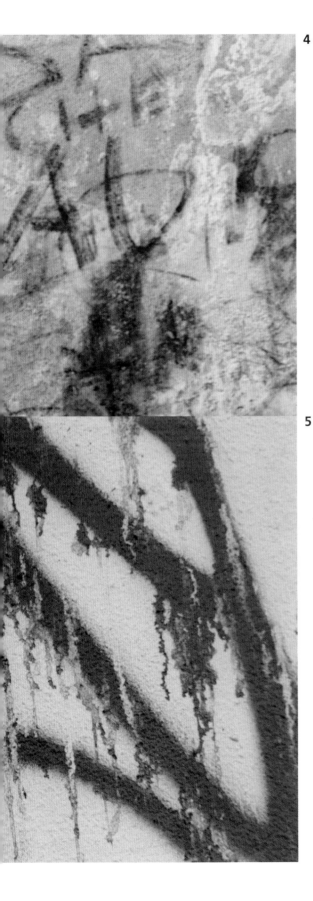

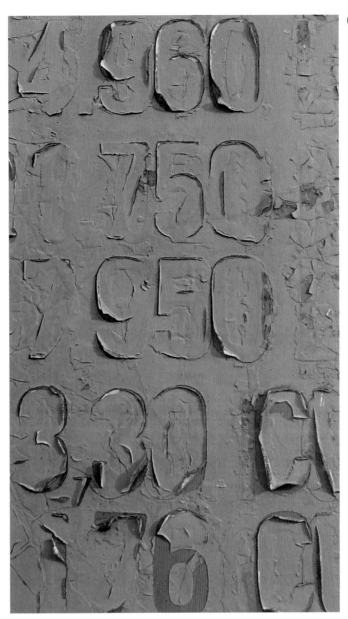

2 The distressed wall makes a good backdrop for this message on a wall on the London Underground.

3 Chinese letters, I think recording sales, scrawled onto an old board behind a stall in a Hong Kong market.

4 A vivid, random montage of scribbles and letters left by children on the outside of a wall.

5 Purple graffiti marks scribbled onto a wall in London.

6 Painted and peeling numbers found on the side of a skip.

7

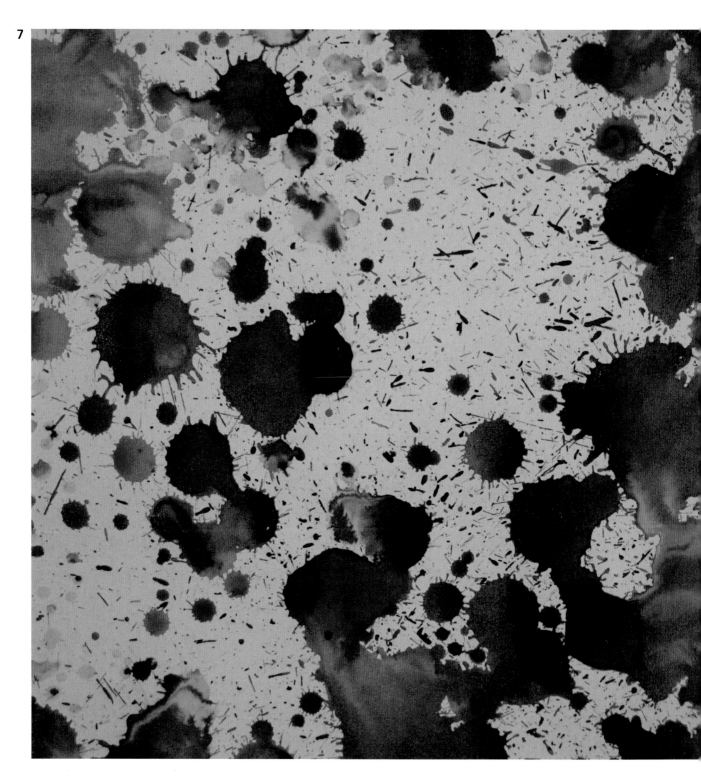

7 *Coloured ink drip and splash marks found in an art studio.*

8 *Words written, and subsequently randomly reshuffled, on the side of planks near Outwood, Surrey.*

9 *Printing inks staining the inside of a porcelain sink in an art studio in Redhill, Surrey.*

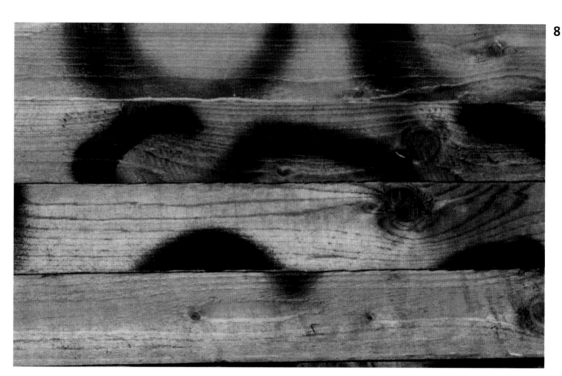

10

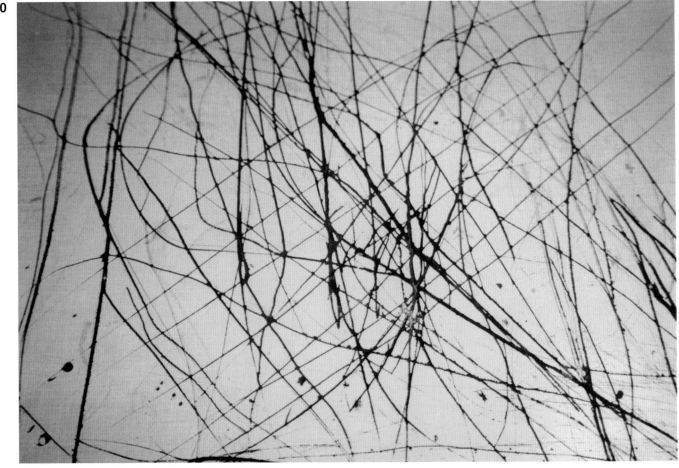

11

10 Swirling, dynamic slashes on a leatherworker's bench in London.

11 Strong, graphic, monochromatic daubs of paint on a lamppost in New York's Central Park.

12 A bold splash of paint discovered under a stairwell in Kent.

13 Urine splashes randomly stained this old bathroom wallpaper. Underlying plaster cracks also show through.

14 Marks on a scaffold board where tiles have been cut with a grinder.

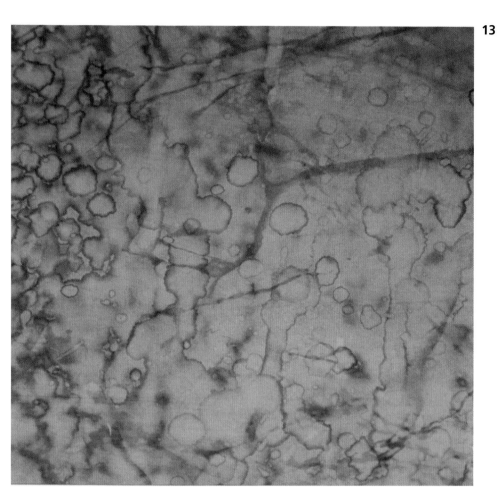

13

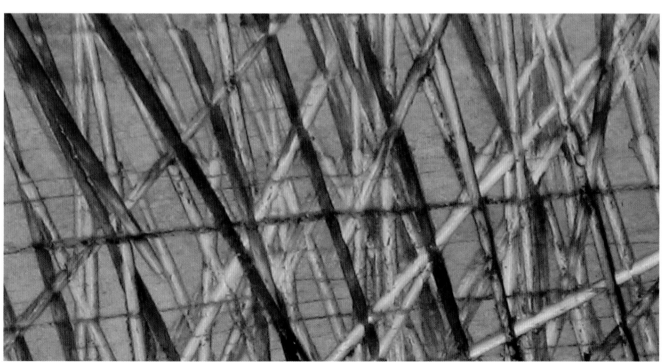

14

107

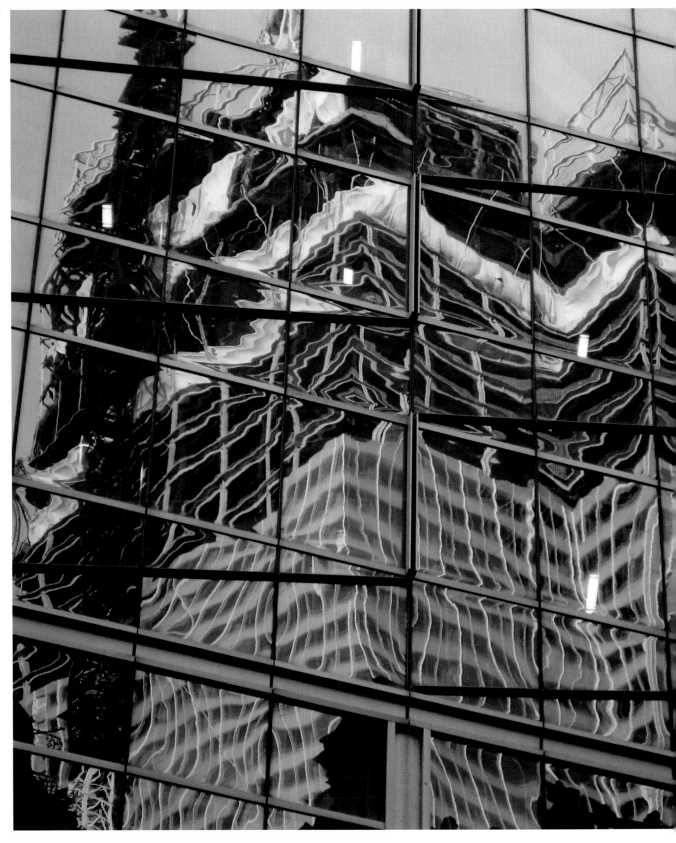

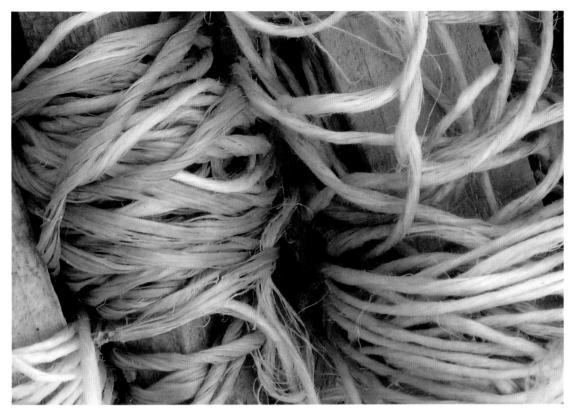

15 A distorted, mirrored reflection seen on a glass skyscraper in New York.

16 Garden string wound round wooden stakes.

17 Charcoal-grey rubber-tyre marks, and a footprint, on white and yellow road markings on Brooklyn Bridge, New York.

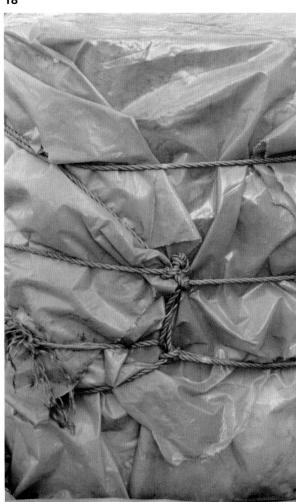

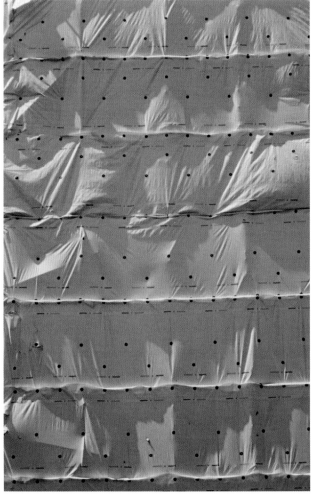

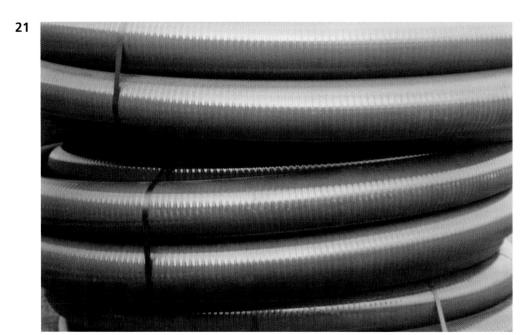

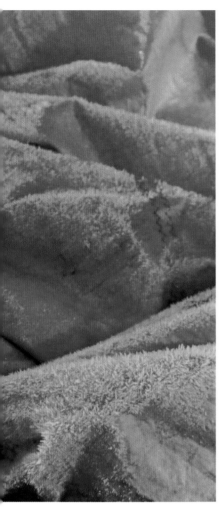

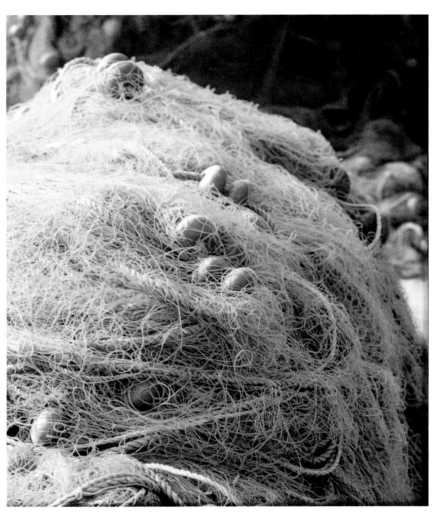

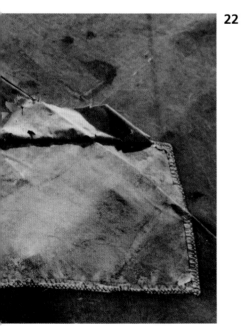

22

18 Building materials wrapped in stiff, opaque plastic. The folds of the plastic have been caught up with the knotted and frayed blue twine.

19 Spotted scaffold protection covering a building near the Post Office Tower in London. Notice the quilted effect and the horizontal demarcation lines where it is secured to the scaffolding.

20 Frost emphasising the turquoise-blue folds and curves on a boat tarpaulin in Chipstead, Kent.

21 Glossy, gleaming, worm-like coils of plastic piping waiting to be put underground to carry service cables or land drains in London.

22 A patched sail found on a boat in Greece. Part of the covering has been torn away, leaving fragments.

23 Rolled bundles of green fishing nets found in Greece.

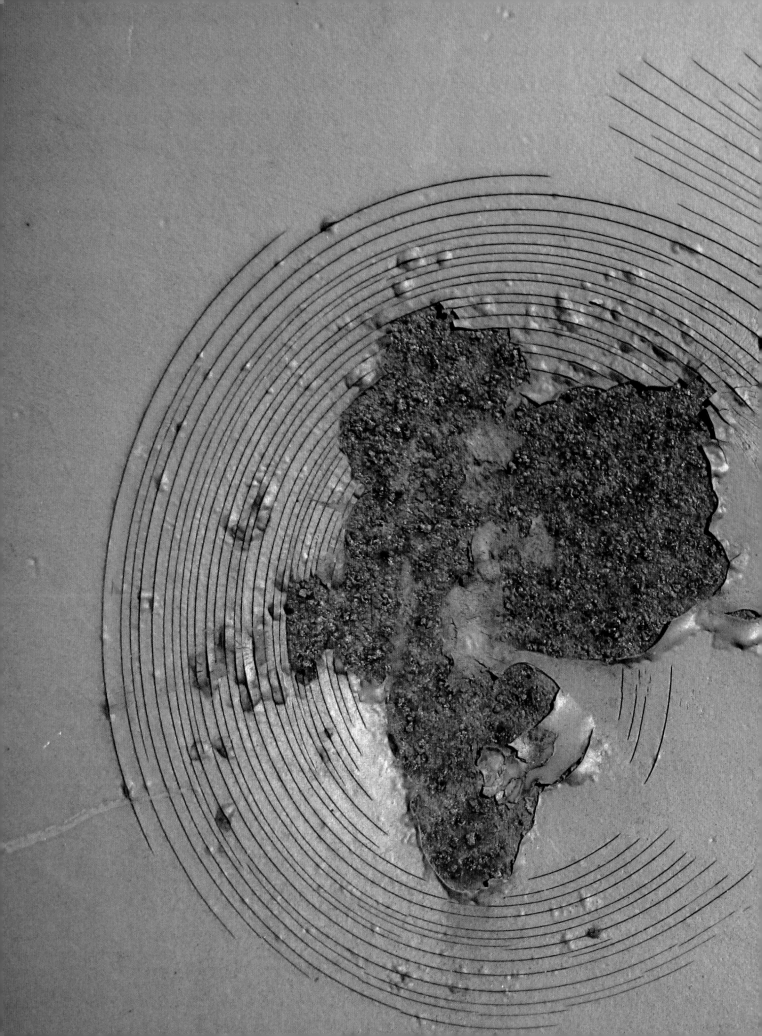

SKIPS

Utterly utilitarian and truly feculent, skips are some of the most unloved, un-meditated-upon objects there are. How many times do we walk or drive past these receptacles, perhaps just glancing at the decaying, unwanted contents to see if there is anything worth taking, oblivious to the exterior shell containing all the unwanted detritus?

Although this chapter addresses skips, it is not actually the skip itself but its bashed-up and unconventionally beautiful walls which fascinate me. I see an idiosyncratic and sometimes incongruous accidental creativity in these surfaces.

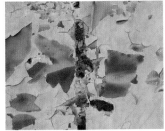

I should mention that there is a cross-reference here – some images of skips have been included in the chapter on rust, as that is sometimes their predominant feature – these iron boxes make a marvellous medium for oxidation. However, in this chapter I have concentrated on applied intentional and unintentional marks and areas where the weather has attacked and eroded the skip's fabric.

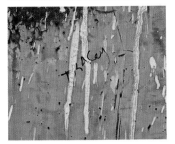

Sometimes, too, selection can be troublesome – finding the best configuration of marks to place in a particular photographic frame can create agonies of indecision on my part. Some of the interesting areas can be too far apart to include within the same frame, so difficult choices and decisions must be made.

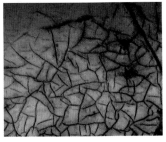

With age comes beauty – I never think to look on the outside of shiny new skips. Some of the newer ones are not worth looking at simply because they have not yet acquired the provenance of dents, inscriptions and gouges that make them so interesting. To me, new equates with boring.

It was the fabulous red-orange rust I saw first on the blue Rochester skip, before registering the other diverse assorted marks it bore. Strange though it may sound, I became alive to skip potential, suddenly seeing them wherever I went, even becoming a bit of a skip groupie.

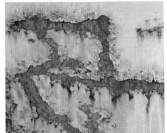

Look at some of the images contained in this chapter. Consider the powder-blue chipped and flaking paint on one image, set against the dark, slowly rusting metal. Observe the way rain has oxidised the steel on another skip, leaching the rust onto the remaining paint, bleaching and fading it in streaks.

A different skip has straight graphic lines of faded writing contrasting with the almost tessellated, chipped paintwork. Notice the small intriguing

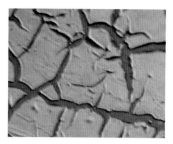

message 'Chris j's home x' written on the side. Is this implying that this skip should be Chris j's home, or that Chris (he or she?) has gone home, or could it be some form of code? And why the tiny kiss? There is also the name 'Tracey' written in small, timid-looking black letters on the white-splashed skip. Could these two names be connected? Do Chris and Tracey know each other? Why would anyone jot their name on a skip anyway? Maybe I am reading too much into it, but it is fun to speculate.

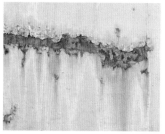

I think my favourite skip in this set of images is the one I found in a car park outside a supermarket in Surrey. Some areas have the remains of writing but others have become blotched with the beginnings of rust; the weather-faded muted rose-pink paintwork undercoated in some areas with green-blue, crusted and re-ornamented with additional careless splashes.

Impact marks, possibly from a flying stone or shard of metal have started the directional crazed lines on the blue skip side featured at the start of this chapter. Rust has formed in the damaged areas, resulting in swirling, almost perfectly circular marks on one site but straight lines on its neighbour. There are also random lines beneath, where no visible damage can be seen. I cannot understand why the paint has behaved in this curious way, but love the fact that it has.

It looks as though one skip has had a topcoat of white paint applied over the base coat of yellow. Strange to paint white such a potentially dirty item as a skip, when a darker colour would seem more appropriate. The white paint is peeling away, leaving only a few remaining shreds, and rust is appearing on the dented and scratched areas. Blue spray paint can be seen on what is left of the white paint.

Rhapsodising about skips does sound strange, but bear with me and suspend your disbelief for a while. Ignore the contents, detach yourself from the meaning of the object you are examining, and keep an open mind as to what you may discover. You may well find small gems amongst all the dirt. Take some time with the next lonely, unappreciated, forlorn and well-used skip that you see; no need to touch – just use your eyes or a camera. You may well view it in a surprising and totally new light.

1 *(Previous double page) Rust on a skip exterior showing directional, crazing lines.*

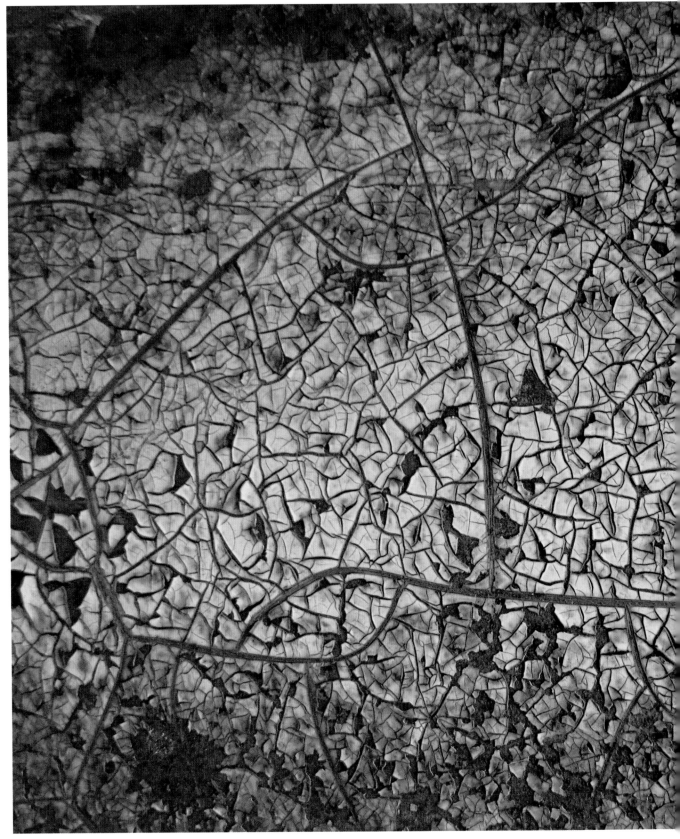

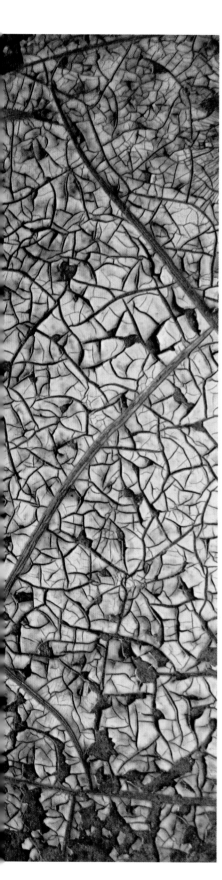

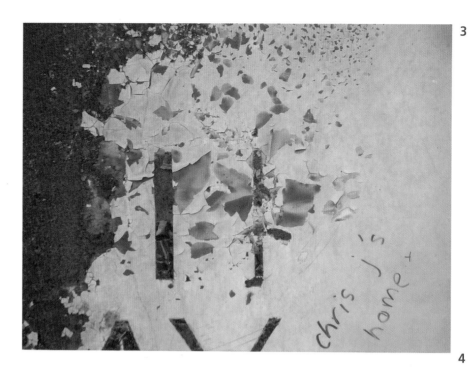

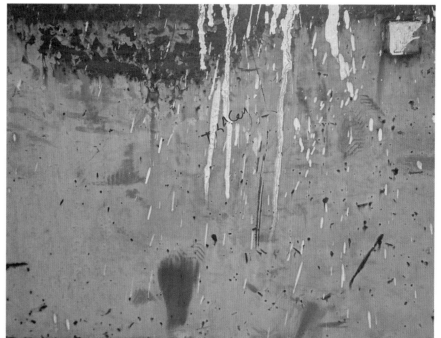

2 Rusty skip with crazed blue paint.

3 Paint has flaked away, haphazardly contrasting with the straight graphic lines of the vanishing writing.

4 Sun-bleaching and rust erosion has not been so severe. White splashes give a feeling of movement and a focal point.

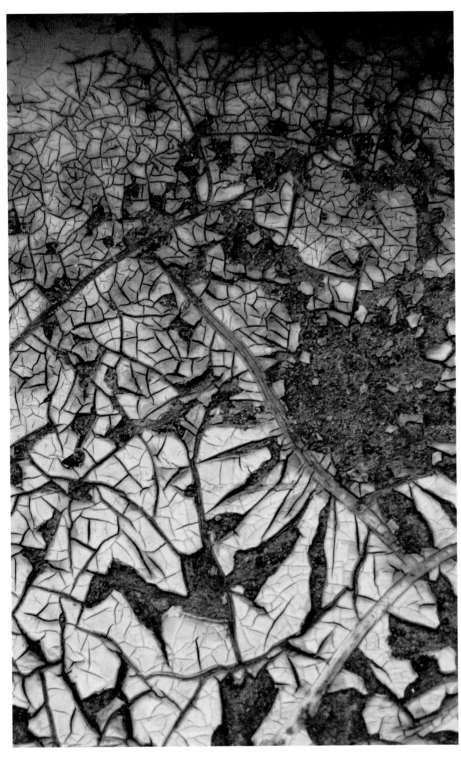

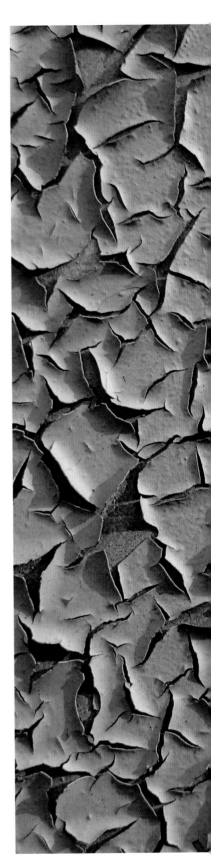

5 Crazed blue paint on a skip exterior.

6 Peeling, crackled paint on a skip in Redhill, Surrey.

7 Skip exterior showing crackled paint, also in Redhill, Surrey.

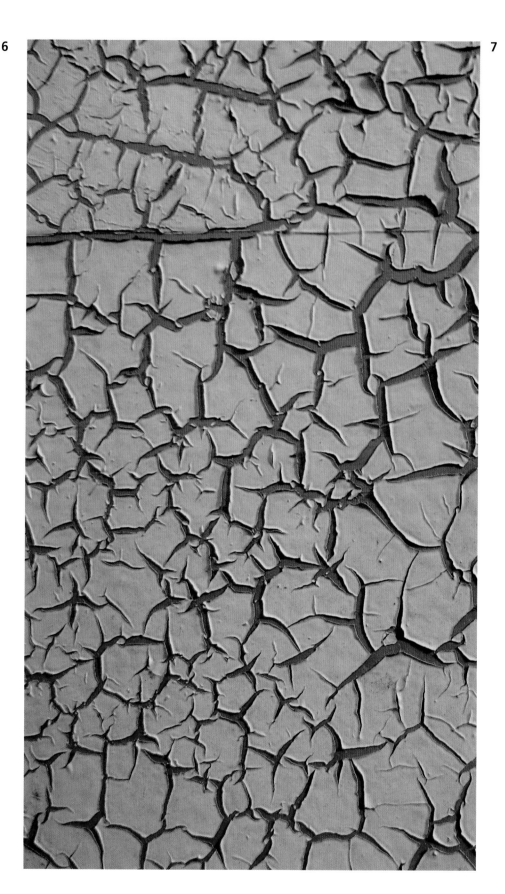

8

10

9

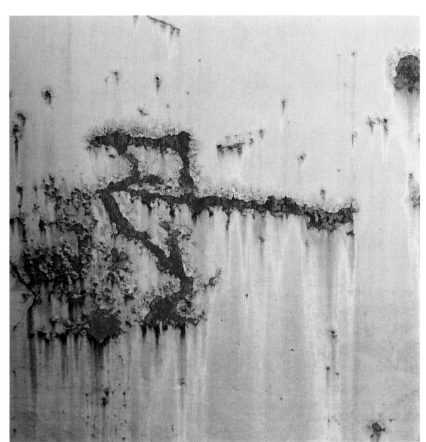

12

11

8 & 9 *The colours on this Reigate skip are brighter and clearer, and some remnants of writing are still visible.*

10 *Colours have become softened and blurred on this crusted surface.*

11 *The same skip surface – notice the dark-pink lines.*

12 *Leaching rust stains and faded paint have muted the colours on this skip.*

13

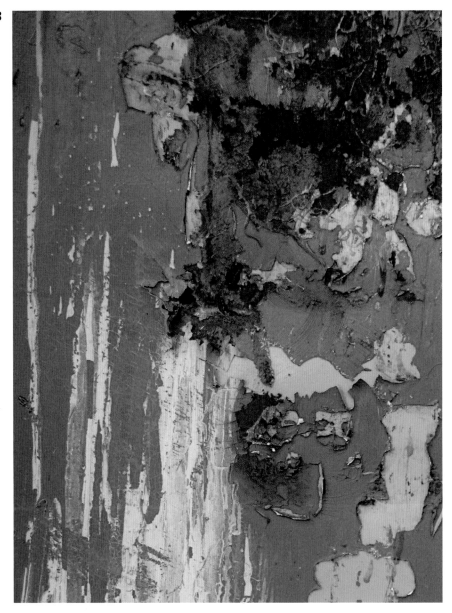

14

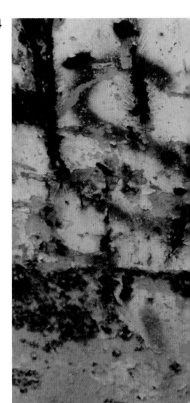

16

13 Blue skip with vivid splashes, rust and peeling paint.

14 A confusion of sgraffito-like marks scoring the painted metal. Blue spray-painted lettering adds to the layered textural effect.

15 Paint has cracked into regular lines, revealing the undercoat. The lines remind me of river tributaries seen from space.

16 & 17 The same skip with small clashing areas of red either exposed or painted on top. I like the asymmetry of the mustard-coloured block of colour on the top left-hand corner of the photo.

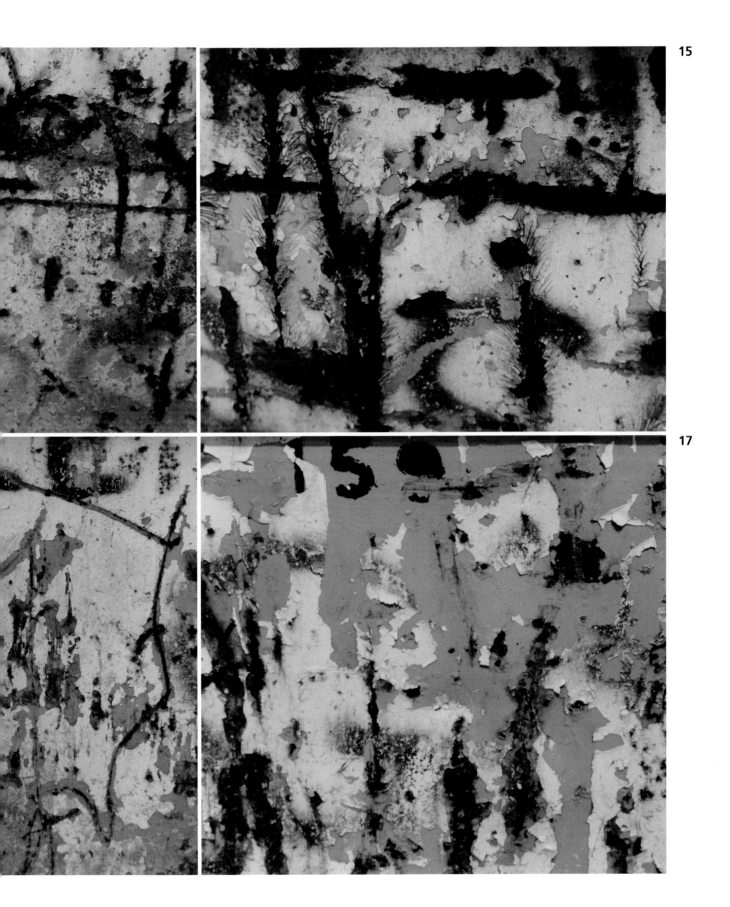

NOTICE BOARDS

should qualify what I mean by notice boards. I do not mean neatly organised boards with current and updated information pinned or pasted onto them. Nor do I mean boards that are regularly in use, tidily maintained and well cared for.

I mean boards which have been gloriously neglected or misused, or have been the subject of fly-posters, or boards that have layers of information being gradually destroyed by time and the weather. I like to see posters which have been carelessly stripped or torn off to make way for the new ones. Notice boards which have layer upon layer of garish, colourful advertising, one jumbled upon another, where fingers may have peeled away at irresistibly torn corners and edges to see what lies beneath. Boards that give hints of previous activities they have advertised screaming out to be noticed when plastered anew; different and new adjacencies creating new meanings.

Boards such as some of those depicted in this chapter show slices of life and give an enigmatic, incomplete history, provoking thought about the hopes, wishes and aspirations of those people who put the posters there in the first place.

Political rallies, rock concerts, festivals and fêtes can all play their part in poster advertising. I often wonder how long some of them have been there, when there are no obvious dates to be seen. However, the content of posters in a completely different language, such as those found in Hong Kong, can only be guessed at, thus adding to their mystery.

Sometimes some of the tattered information found on these boards seems to be roughly themed, giving them a strange idiosyncratic identity – pop concert upon gig information, over New Year's party celebrations, across political campaign, on top of poetry readings, obscuring civic information notices, and so on – though it is difficult sometimes to decipher them all.

There are tantalising glimpses from parts of posters with faces, names and perhaps telephone numbers and addresses under and overlapping each other and peering out through the layers. Colours and shapes can clash in a wonderfully cheerful cacophony of dated half-information.

Such an eclecticism of visual representation tends to evolve gradually over time. Some boards have taken years of neglectful input to

arrive at the state of interesting clutter that they now represent. I imagine that no one has bothered to carefully take down and dispose of the old information, or remove any pins or staples, before putting up the new. It is much easier simply to tear it down and paste or pin the new poster on top. Time and the weather have then taken their toll.

Interesting montages of information can arise from some notice boards, sometimes leaning towards the surreal. Italian lettering printed on a grey background is torn asunder, revealing a colourful small army marching through the centre such as was found on one such board in Venice.

Some notice boards resemble abstract paintings. Blank areas have shreds of paper half-attached or marks where glue has been left after paper has been torn away. I find these beautiful and see them as small works of found art. I am particularly fond of some black-and-white examples I found in London – the paring down of colour enhances the ability to concentrate on shape, form and texture without distraction.

In contrast, a board on the wall of an art room in Epsom, Surrey was covered in brightly coloured scraps of paper from a multitude of different artworks. Staples littered the board, adding to the general effect. No one had taken down the previous work; it had simply been torn off to make way for the new, leaving behind the shreds of previous paintings. Large sheets of blank paper were about to be mounted over the fragments, giving a clean sheet, ready for the next year's output. I so enjoyed the large busy area that it seemed a travesty to me to cover it up, but I was grateful to have the chance to record some areas before their eventual annual disguise.

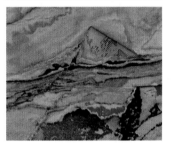

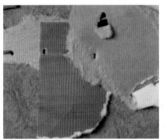

Next time you are walking past a neglected or much-used notice board or billboard, stop, look and absorb. Think of this collage of paper as a social commentary for the area – you can contemplate what it might all add up to, or just enjoy the shapes and colours for their own sake.

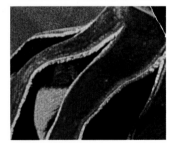

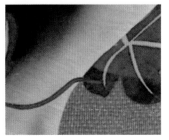

1 *(Previous double page) The last remaining tatters on a New York notice board.*

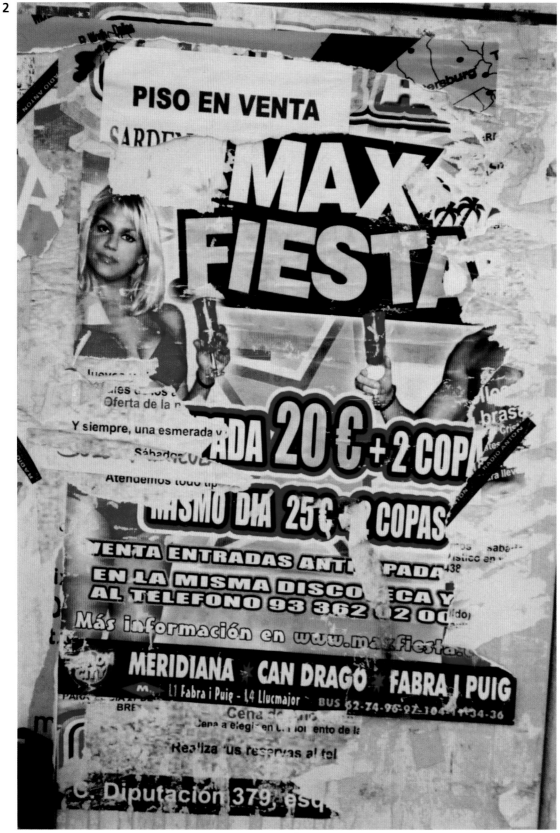

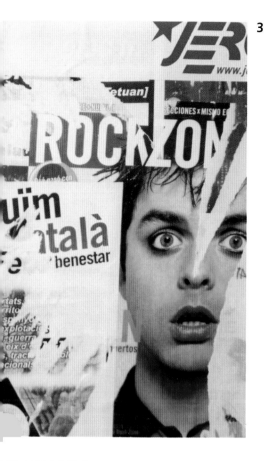

2 The blonde model in this Spanish poster offers a toast. Only the arm is left on her male counterpart. Green remnants appear in a strip at the top.

3 & 4 Bright colours and the man's shocked face drew my attention to this poster in Barcelona.

5 A French poster with strong colours. Note the droopy, peeling corner of the paper.

6 (Overleaf) A Venetian poster showing a woman's face peering out; note the rippled, cockled paper of overlaid information.

Fisco facile

Il CAF UIL aiuta te
e la tua famiglia per:

- modello 730
- modello **UNICO**
- dichiarazione **ICI**
- modello **RED**
- chiarazione **ISE-ISEU**
- enzioso fiscale tributario
- iarazione di successione
- ssistenza pratiche
 voratori domestici
- e per tutti gli altri
 empimenti fiscali

eni al CAF UIL
E TI SENTIRAI

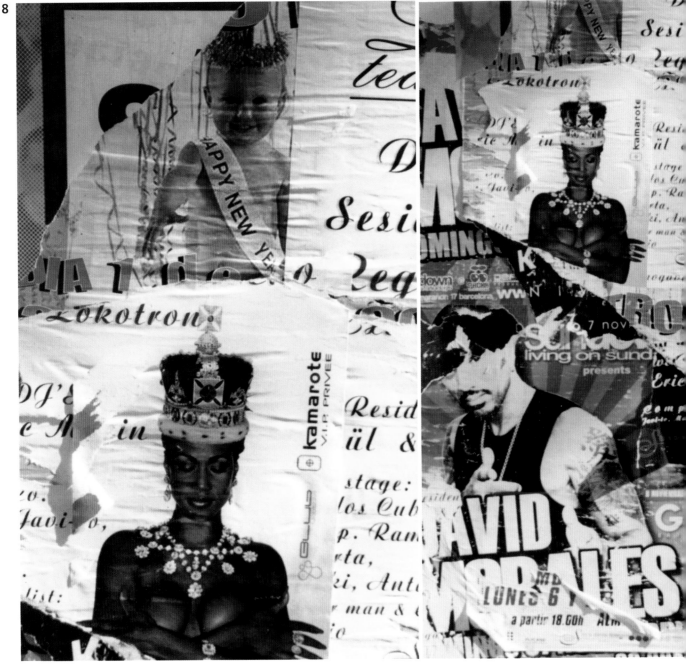

7 & 8 *The first section of this billboard, also in Barcelona, shows close-ups of the baby sitting above the crowned pin-up. A vested man stands beneath them on the next image.*

9 *Layered poster in Florence, Italy.*

10 *A bright-pink scrap of ripped paper, and part of a face peering through the tatters, feature on this poster in London.*

9

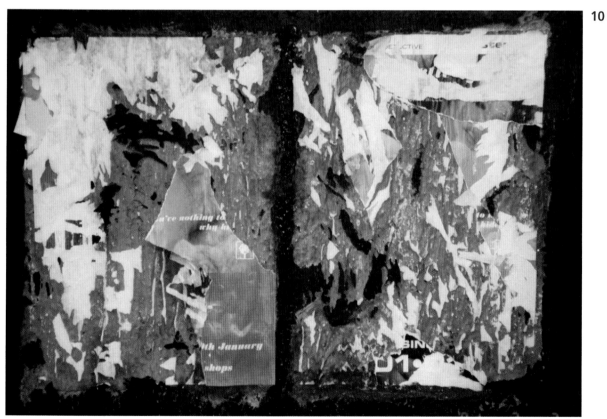

10

133

11 Rallying posters found in Venice.

12 A torn monochrome notice found in London, with paste remains giving texture. Only white paper scraps and fragments of letters are left.

13

14

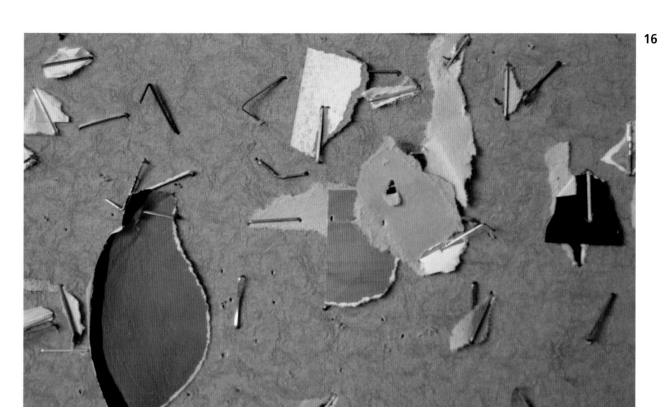

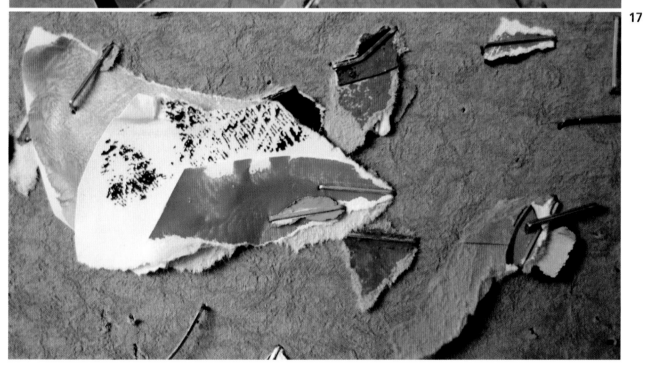

13–15 *This New York poster has white, torn areas edged with colour. The layered edges remind me of a relief map.*

16 & 17 *Bright tatters of painted paper and staples are left on these art-classroom display boards in Epsom, Surrey.*

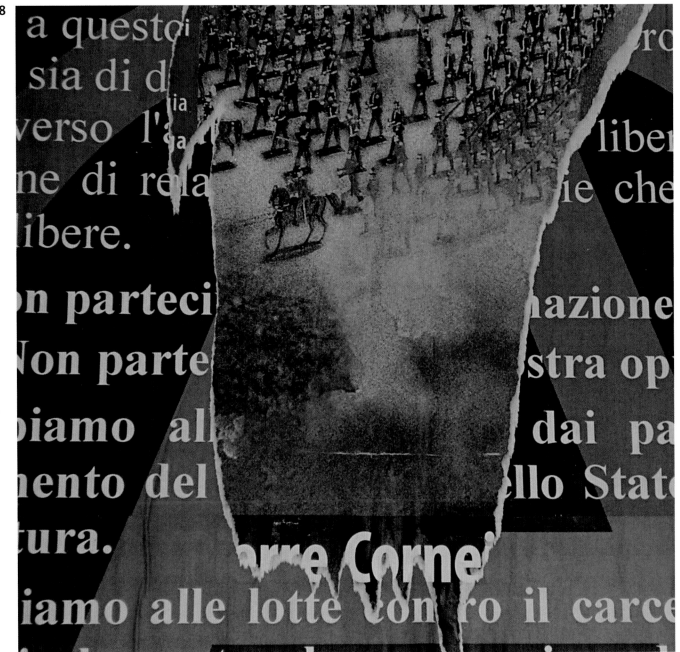

18 Soldiers in a flash of colour march through the grey-coloured gap in the lettering on this Venetian notice.

19–22 Different areas of a multicoloured notice board in a London Underground station passageway.

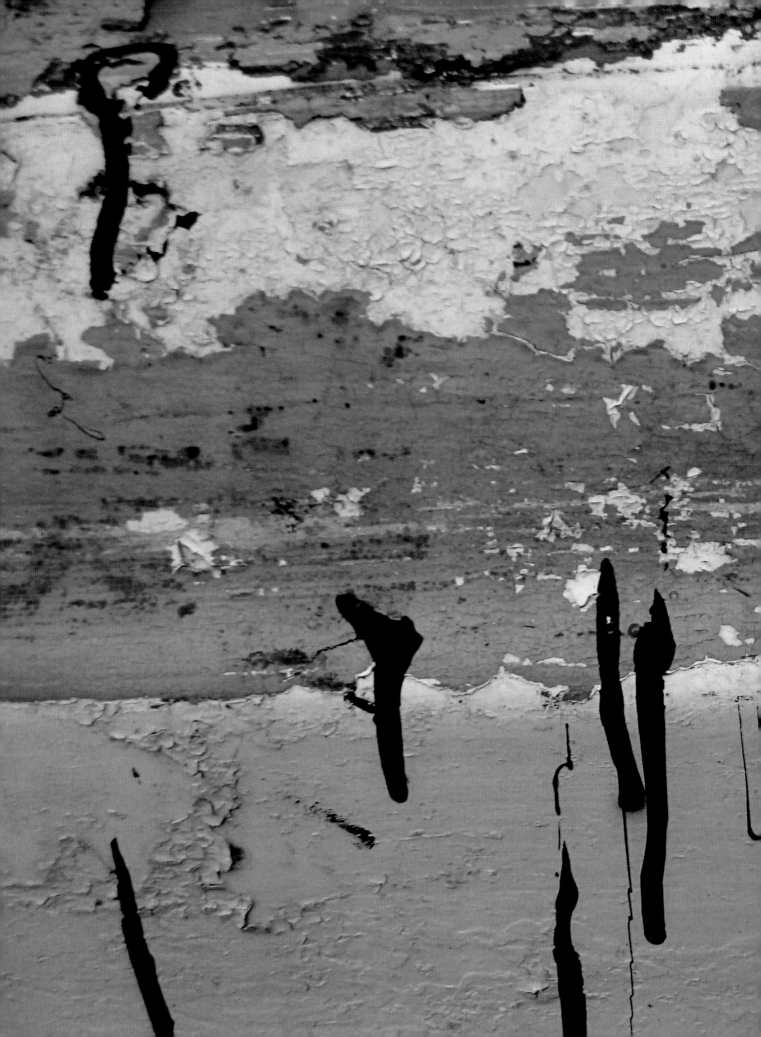

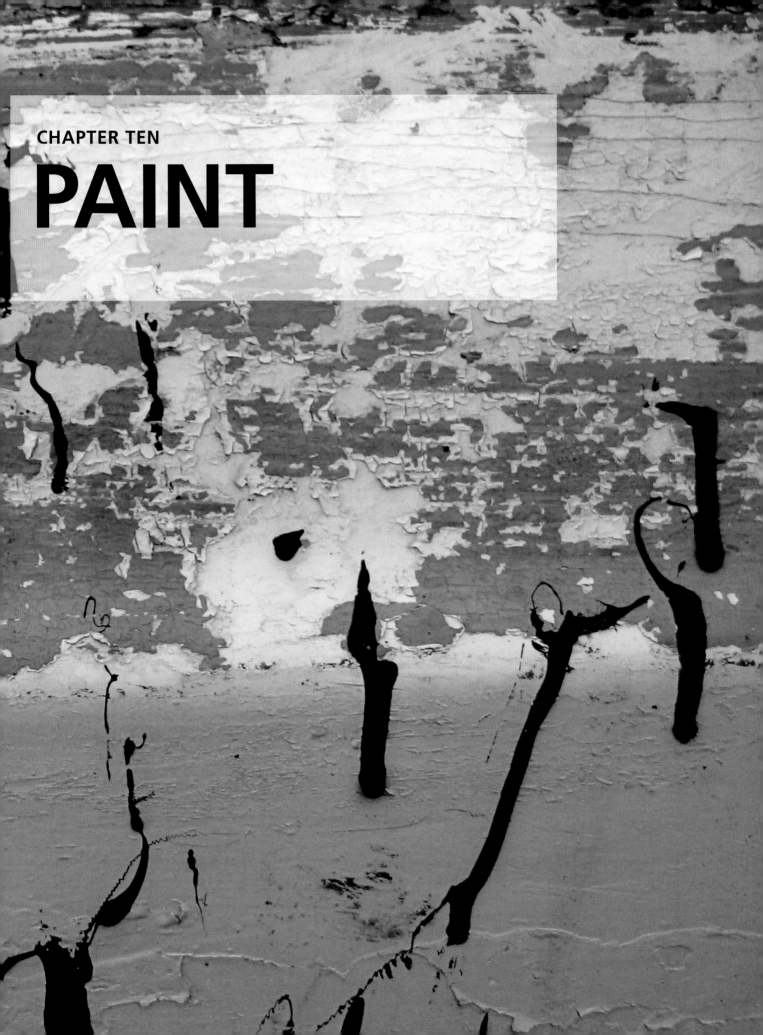

CHAPTER TEN

PAINT

Bloated, blistered, bubbled, cracked, smooth, lumpy, scraped, scratched and scored, paint is the surface upon which an object's history can be incidentally recorded, producing weather-beaten, storm-tossed surfaces that have seen action. Paint can be used to conceal or reveal, to highlight or to hide.

Look at the inverted hull of a boat which has been brought ashore. Paint may have inadvertently been rasped away as the boat has been repeatedly dragged across a sandy or pebbly beach. Scrubbing and scraping away of barnacle-encrusted areas can result in scratch marks, too, though fortunately, from my point of view, some barnacles remain to ornament the surface on one of the images in this chapter. Perhaps, too, an area has been overenthusiastically regenerated with a new coat of paint or varnish, resulting in careless drips and splashes that bring a new dimension of interesting and contrasting marks.

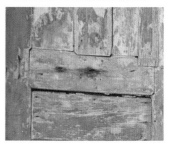

Boats can take quite a battering. The redundant boat hull discovered propped up against a wall has been mended, patched and bolted with wood. Most of the original varnish and paint has disappeared, leaving behind mere remnants of white and red. There might have been a sad end for this boat, but it was now being used as part of the décor in a New Zealand restaurant and was much admired, giving it a new lease of life.

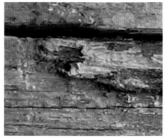

Paint types deteriorate differently, and of course the surrounding environment and conditions have a huge impact on wear and tear. This deterioration can take different forms – some paint seems rubbed or scoured, some flakes away, and some just erodes, showing areas of different-coloured undercoat. This is something I find particularly seductive. Thick applications of paint and more paint where proper preparation has not been undertaken can result, over time, in gorgeous peeling. Subsequent delamination of layers sometimes reveals the bare wood beneath, such as can be seen in the image of the windowsill where the paint has curled away, showing the deeply grooved wood grain beneath.

One intriguing example was found on an internal Victorian door waiting to be stripped and renovated. The interaction of the white paint and the underlying varnish gradually formed a pattern – a cross between a jigsaw puzzle and an ice floe. It seemed rather a shame to strip it back to the bare wood, denuding it of marks so slowly evolved.

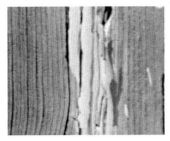

There seem to be quite a few external doors in my collection, no doubt because these take the brunt of the weathering and are both visible and accessible. I have chosen to include the whole door in a couple of instances, as it is useful to see the paintwork in context, and these particular doors, and in one case window shutters, are intrinsically pleasing structures to look at. Consider, too, the image of the battered, blue double doors in Greece, with five separate letterboxes, tantalisingly leading the eye onwards to wonder what may lie beyond the open door. How satisfying it might be to explore.

I particularly enjoyed seeing the Cornish door, tucked away as it was down a winding narrow street. The door itself, scoured by weather and time, was distressed, with the topcoat of mottled jade-green paint peeling away to reveal the turquoise-blue undercoat. In addition, the surrounding walls were ornamented in dappled green mildew and mould.

I have included part of a door panel found on the South Island of New Zealand, discovered whilst sheltering from driving rain. It even had a small colony of bright-yellow and sage-green lichens living along the areas of bare, stripped wood and pea-green paint.

Sometimes, too, paint is added when it is least expected. On a New York street, to my amusement and surprise, I stumbled upon a row of crazily decorated fire hydrants. Someone, perhaps a Jackson Pollock aficionado, had drizzled and dripped white and blue paint onto the cheery cherry-red of the hydrants. It was as though someone had undergone a whimsical moment of artistic frenzy determined to leave its mark on all this street furniture.

To me, these are not damaged surfaces but areas deserving closer and more thoughtful attention – they are teeming with beauty. Ignore perfect paintwork – it has little to give – but focus your camera lens and eyes on areas where neglect has occurred.

1 (*Previous double page*) *The upturned hull of a boat in Swanage, Dorset. Careless black splashes of paint have added texture.*

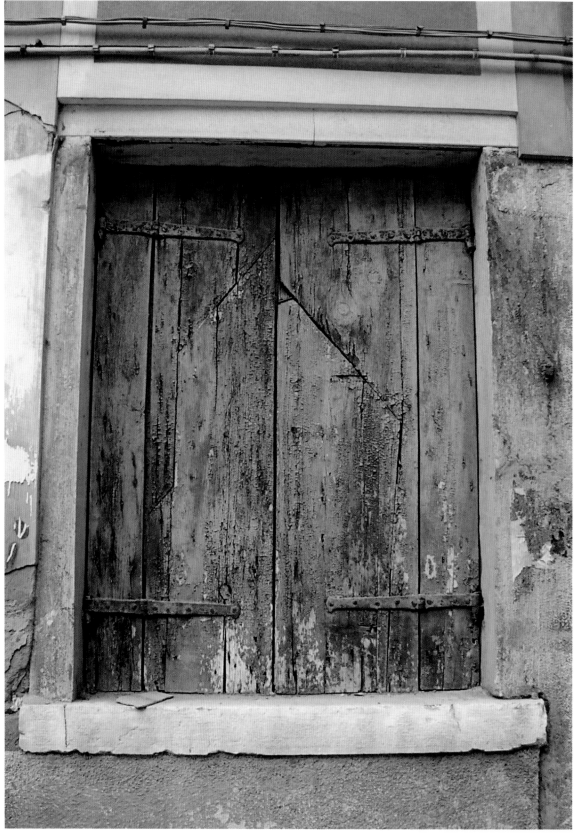

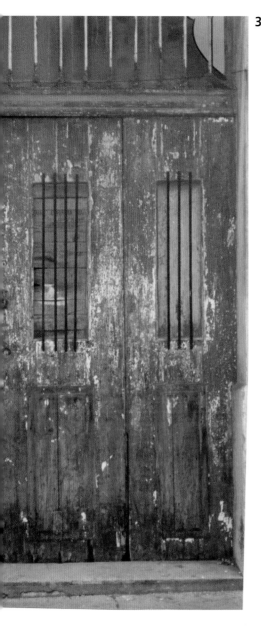

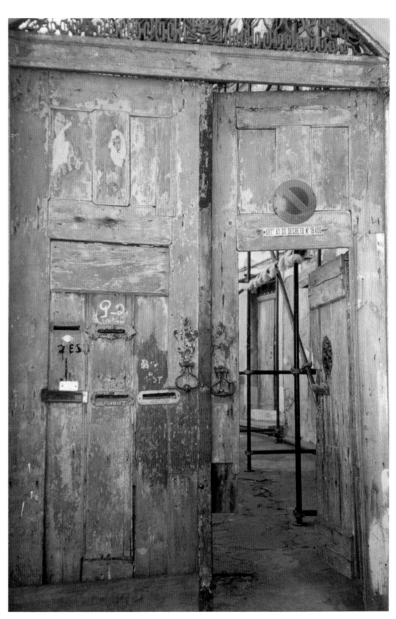

2 Wooden window shutters with paintwork bleached by strong Venetian sunshine.

3 The paint on these three Polish doors in Krakow is faded, revealing white undercoat and the battered wood beneath.

4 Flaking paint on Greek doors, with an interesting arrangement of letterboxes.

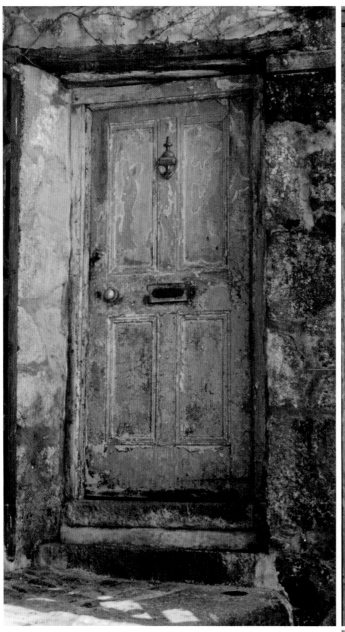

5

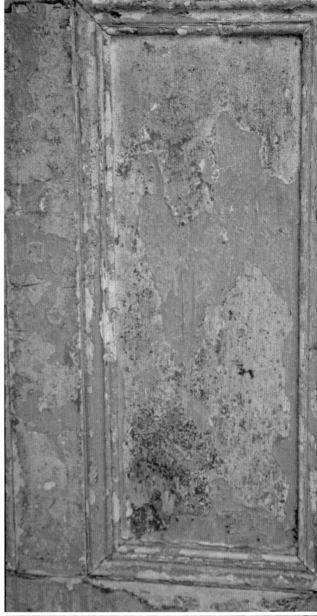

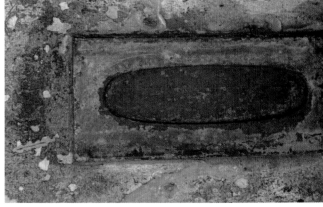

5 Turquoise blue-green paint on a Cornish doorway. Note, also, the colours on the mildewed surrounding walls.

6 One panel of the Cornish door.

7 The letterbox itself in the same doorway.

8 Remnants of paint clinging to a post in Dorking, Surrey.

(Overleaf)

9 Scoured white paint revealing the red undercoat on a storage door panel in New Zealand.

10 The side panel of the hull of a redundant old boat. Note the configuration of bolted wood, and battered white and red paint fragments.

11 A door panel in Moeraki, New Zealand. Look at its palette of peachy-pinks, oranges and terracottas.

9

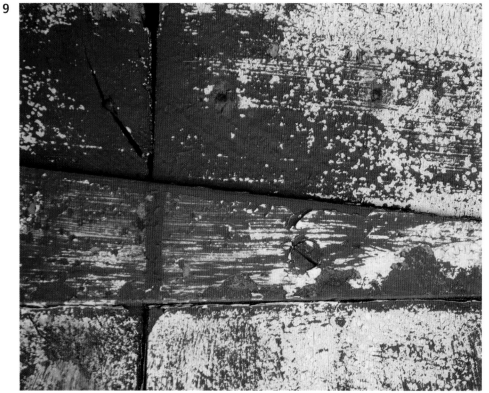

10

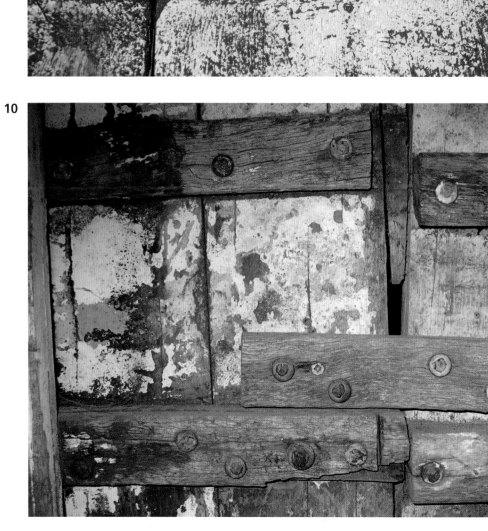

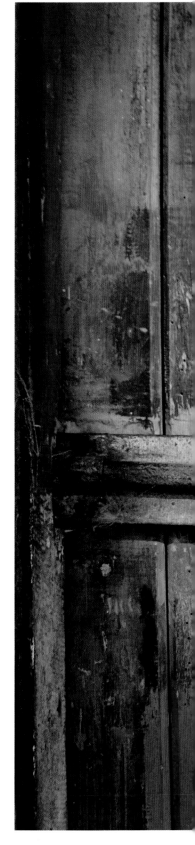

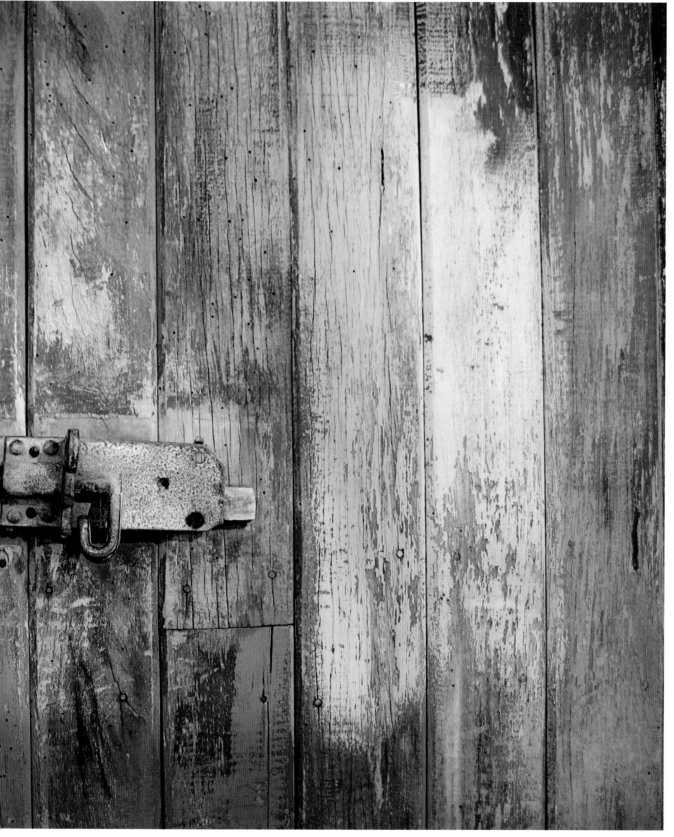

12

13

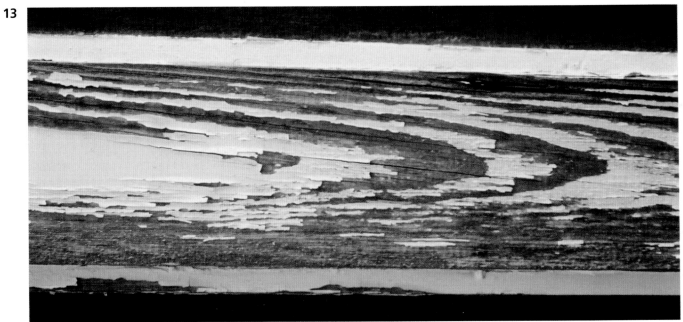

12 The interaction of varnish and paint on this Victorian door has gradually made these patterns.

13 Paint remnants have clung to the grain of the wood on this wooden strut.

14 The hull of a boat in Swanage, Dorset. General wear and tear has created these areas of erosion.

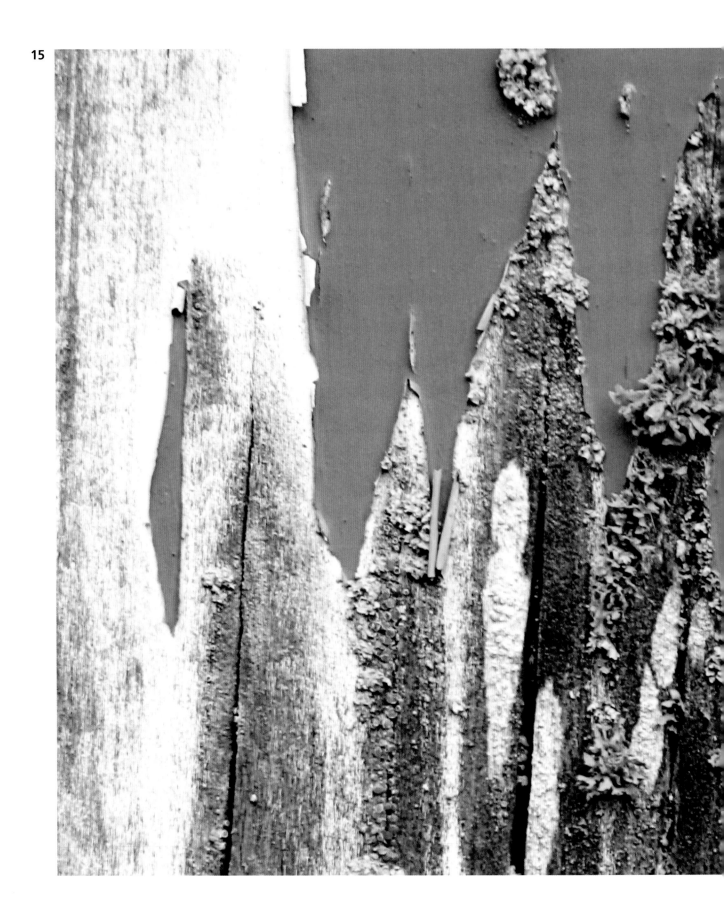

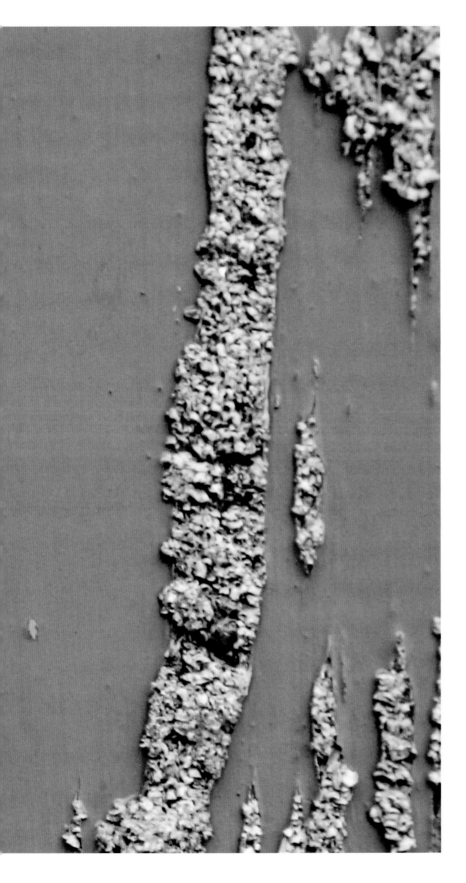

15 Yellow and green lichens have colonised the bare areas of wood on this pea-green painted door panel.

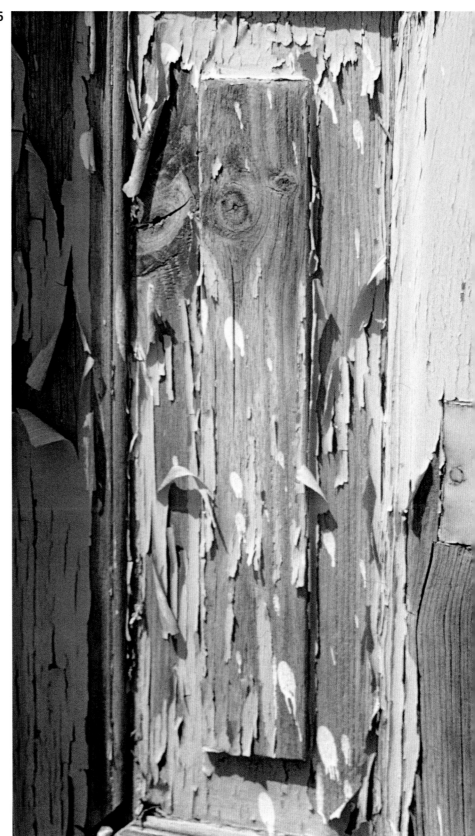

16 Part of a sun-distressed door panel found on a Greek island.

17 Paint peeling away on a windowsill reveals heavily grained wood.

18 Splintered paint on the hull of a boat in Chipstead, Kent.

(Next double page)
19 The upturned hull of a Greek boat. Notice the careless varnish dribbles.

20 Barnacles cling to the hull of an upturned Greek boat.

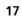
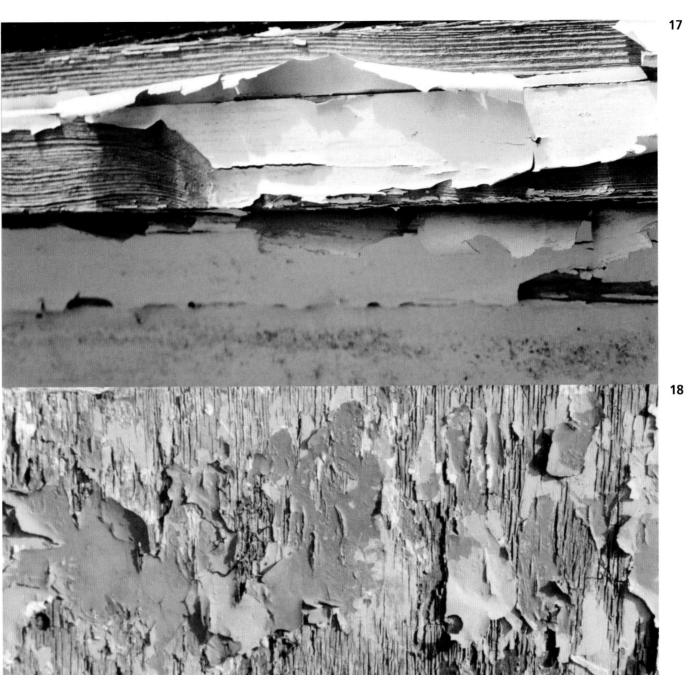

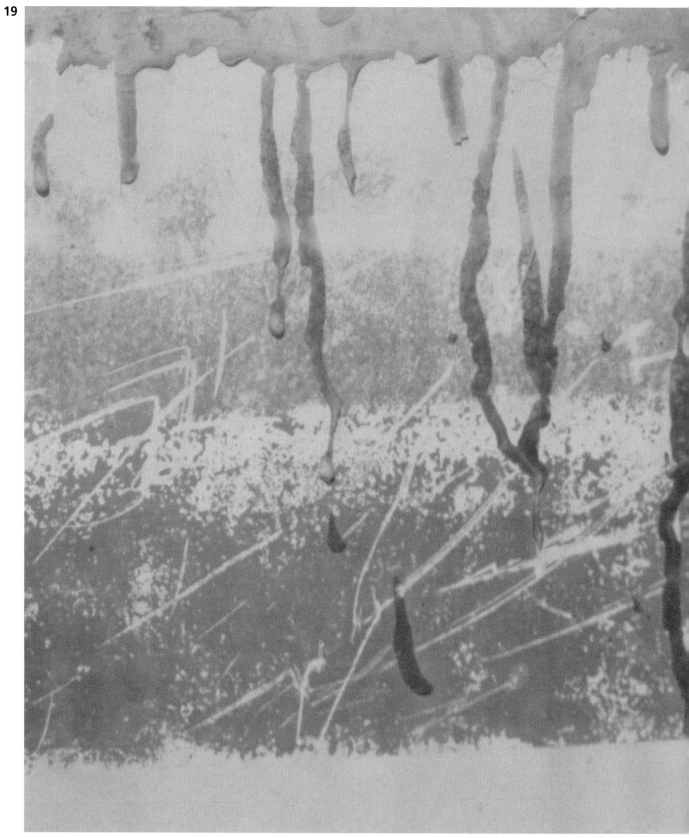

19

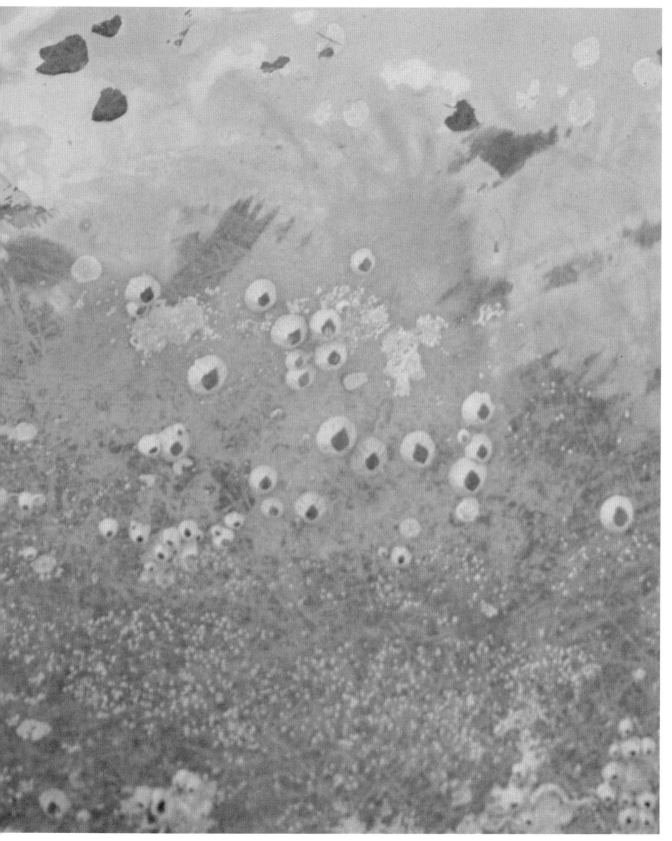

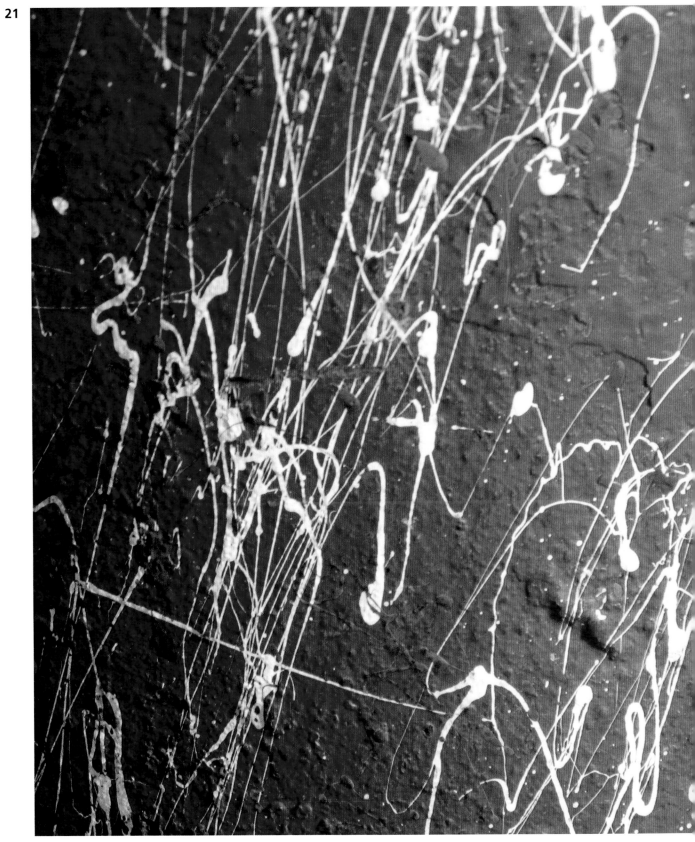

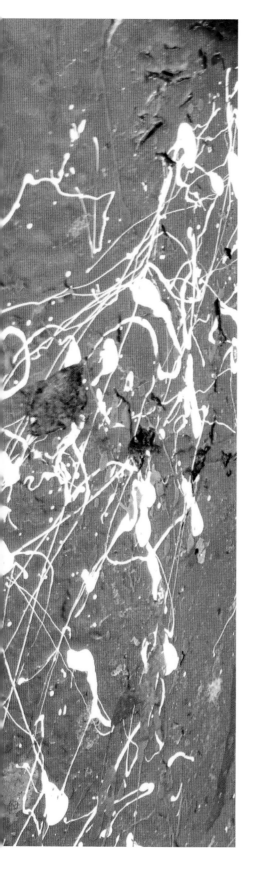

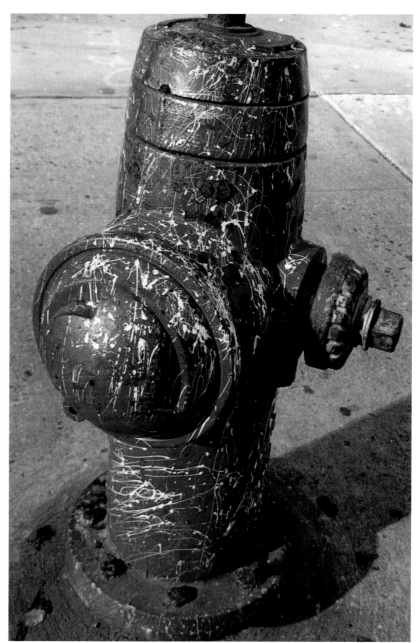

21 Detail from one of the 'Jackson Pollocked' red fire hydrants found in New York.

22 One of the fire hydrants.

23 (Endpiece overleaf) Moss-covered corrugated roof in Avebury, England.

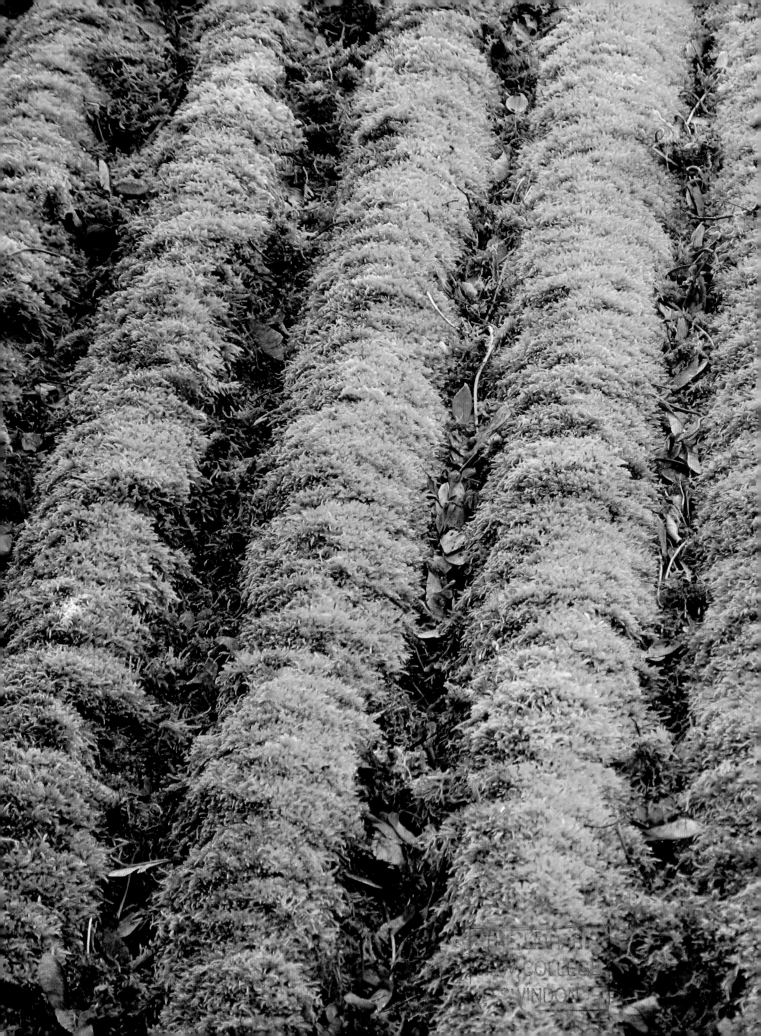